IMAGES of America

AFRICAN AMERICANS IN FORT WAYNE

THE FIRST 200 YEARS

AFRICAN AMERICANS IN FORT WAYNE

THE FIRST 200 YEARS

Dodie Marie Miller

Copyright © 2000 by Dodie Marie Miller
ISBN 978-0-7385-0715-6

Published by Arcadia Publishing
Charleston, South Carolina

Printed in the United States of America

Library of Congress Catalog Card Number: 00-106892

For all general information contact Arcadia Publishing at:
Telephone 843-853-2070
Fax 843-853-0044
E-Mail sales@arcadiapublishing.com
For customer service and orders:
Toll-Free 1-888-313-2665

Visit us on the Internet at www.arcadiapublishing.com

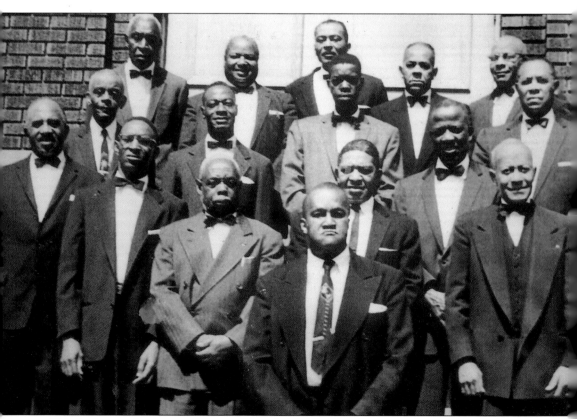

This is the men's chorus of Turner Chapel A.M.E. Church, year unknown. In the last row, second from left, is the author's grandfather, Samuel S. Dixie. Next to him on the right is Al Harris, an accomplished pianist; front, center is Carl Wilson; and in the row behind him, third from left, is John Nickols.

Contents

Acknowledgments 6

Introduction 7

1. Early History of Blacks in Fort Wayne 9

2. Early Fort Wayne Memories 21

3. Black Churches in Fort Wayne 103

4. Black Firsts in Fort Wayne 115

Dedication

This book is dedicated to the memory of my father, Willie Roger Miller Sr. (1923–1982). Even though we only had nine years together, he made me think that all I created and achieved was wonderful. He was also one of the brave individuals who migrated from Alabama to Fort Wayne to make a living at International Harvester.

Acknowledgments

There are some people whose help was invaluable during the completion of this book. I would add that I feel blessed to have had the opportunity to write a book of this nature.

Heartfelt "thank yous" go to my family, especially to the following people: my mother, Elzora (Dixie) Miller, for moral support and for being my unofficial writing coach; my sister, Reba F. Ervin, for technical support; my nieces, Rhea and Alicyn Ervin, for being very helpful when Aunt Dodie needed them to be; and to my friends Tim Cantrell, Jason Hackbush, and Elaine Linder, who never doubted my ability to write.

The following organizations and individuals were extremely helpful in assisting me with the acquisition of images and information: Dr. Miles Edwards and Mrs. Hannah Stith of the African/African American Museum (Fort Wayne); Ann Fairchild of the Fort Wayne Historical Museum; and I am indebted to Mrs. Margaret Myrick, Mr. Delmus Wilcher, and Mrs. Dorothy Dixie for sharing their memories with me.

Introduction

One volume is not sufficient to tell the story of African Americans in Fort Wayne. The story of Blacks in Fort Wayne is over two hundred years old at this point. The many lives involved in so many years could probably each fill a book of their own. So what is here is a very condensed version of Fort Wayne history, seen from the perspective of people of African descent.

I have attempted to highlight some of the little-known facts about Fort Wayne. These facts are presented by way of oral histories, background information for the photographs, and from research material given to me from the Historical and African/African American Museums.

The book begins in roughly 1794, where evidence exists of the first black citizen of Fort Wayne, who was here when the Fort was an active defense site and not just a tourist attraction. The volume continues until about 1965, where the Black "firsts" in Fort Wayne are highlighted. Of course, more Black firsts have occurred in Fort Wayne since the middle of the 20th century and into the 21st century, including the hiring of the first black fire chief in 1999. This is certainly a history that will need to be updated as the years progress.

One

EARLY HISTORY OF BLACKS IN FORT WAYNE

A portion of the following is from information collected by J. Randolph Kirby, Ph.D., associate professor emeritus, School of Education at Indiana University-Purdue University at Fort Wayne.

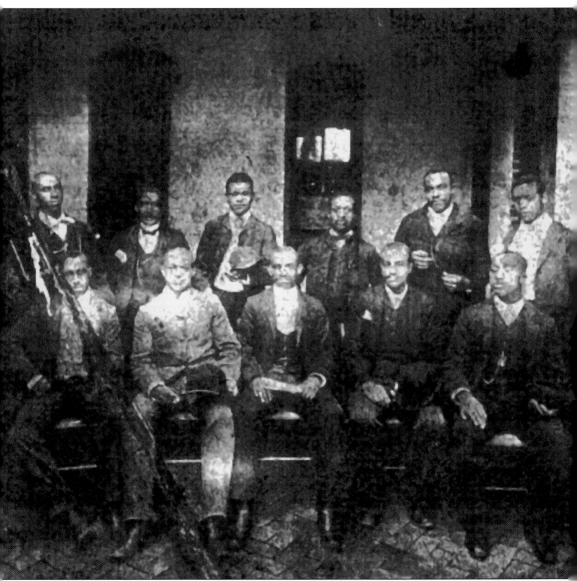

This picture of black waiters was taken in 1894. They were employed by Wayne Hotel.

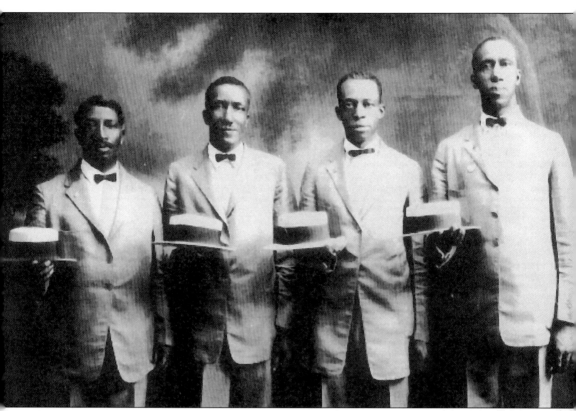
This is a singing quartet. This picture was taken in 1913. George Wilson (on the left) and Arthur Williams (second from right) are included in the group.

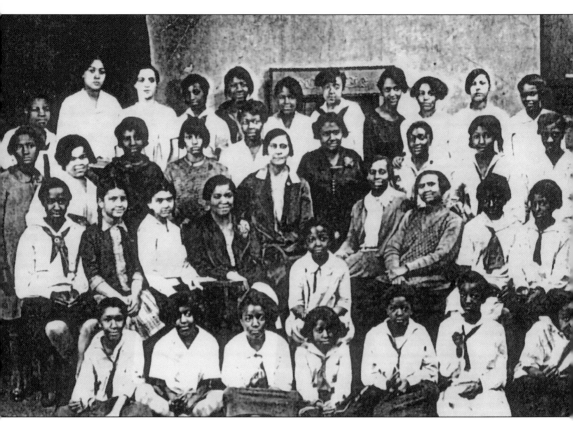
This photo of a Girl Scout group was taken at the Wheatley Center in 1929.

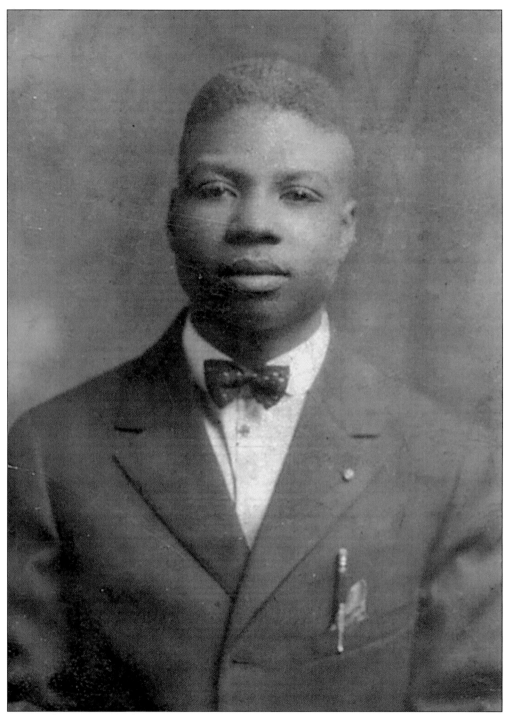
Here is the Reverend John Dixie Jr. on July 27, 1919. He was 16 years old.

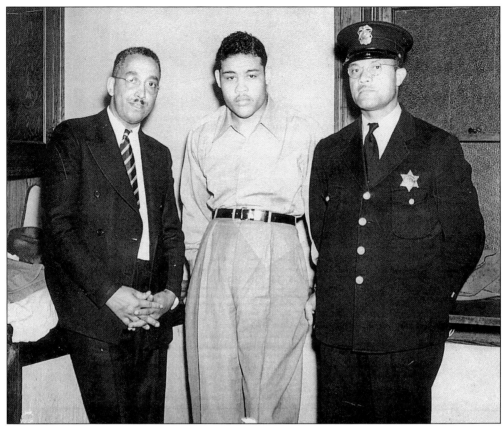
World Champion boxer Joe Louis came to Fort Wayne for an exhibition fight in 1934. Also shown are Edgar Unthank, director of the Wheatley Center (left), and policeman Sam Stuart (right).

Records of blacks in the settlement known as Fort Wayne are few. The African Americans who lived in Fort Wayne prior to 1809 were primarily known, at least in existing records, by their occupations or roles in the military encampments. What is known about early black settlers in Fort Wayne is that despite laws discouraging their permanence, once blacks arrived in Fort Wayne, their numbers increased steadily over the decades.

In the 1700s, a small group of British and French traders and trappers lived on the Spy Run bank of the St. Joseph River. A journal kept by an Englishman, P. Henry Hay, who was visiting from Detroit, told tales of black slavery and slave trading among whites and Native Americans. Records indicate that in 1794, Lieutenant Colonel John F. Hamatramck, the fort's first commander, kept blacks as servants. By 1800, Hamatramck and Captain William Wells, the Fort Wayne Indian Agent, were using blacks as slave labor on their large farm outside the fort. Records of these activities were found in journals and business records of the two men.

The first free blacks in Fort Wayne were Philip Framan, a "bake-man," and two soldiers in the First Infantry Regiment. David Gillen and Joseph Faudree (or Faudril) were army privates listed in the Garrison Orderly Books of 1812–13. Gillen may have arrived in Fort Wayne as early as 1809. Faudree enlisted in the army in Virginia on December 30, 1813. He served in Fort Wayne until he was discharged on April 30, 1815.

In 1820, Reverend Issac McCoy, a Baptist missionary, opened Fort Wayne's first school. Among the school's 25 students was one black child, in addition to the other English, French, and Native American students. The names of the students were not recorded. McCoy does not account for the students' parents, either, listing neither their names nor the occupations they performed. The journal of Reverend McCoy served as a source of information about early Fort Wayne blacks. Reverend McCoy was in Fort Wayne to convert the area's Native Americans, and he thought that colonization was best for African Americans. It appears he actually thought blacks would be happier in the land of their ancestors. Colonization was not popular with area blacks, and there seems to be no evidence to support large numbers of blacks leaving the United States for Liberia.

Regardless of what he thought of blacks, McCoy's journal supports the fact that he interacted with them on a somewhat regular basis. According to a journal entry dated March 3, 1820, McCoy paid a black man in Fort Wayne to care for his horse. On April 11, 1820, a handkerchief was given to him by a black girl named Pricilla Boudin (the handkerchief was to be donated to the Indian mission). And in May of the same year, McCoy had to pay a black man to shine his boots.

Some blacks arrived in Indiana from the south with their owners, who often promised freedom once they settled in Indiana. The blacks became indentured servants of sorts, and under the law it was illegal to sell indentured servants to other people. The law was often broken. Even when slaves were not sold, their indentured servitude contracts were sometimes ridiculously long. Records indicate that two men agreed to very long periods of time—one to a period of 50 years, and another to 90.

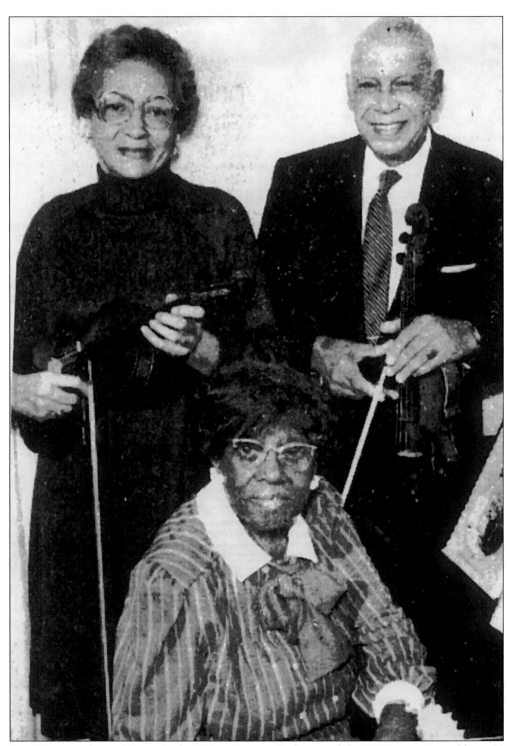

Surviving members of Susan Jordan's Community Orchestra of the 1920s are pictured here 50 years later. They are, from left to right, as follows: Josephine Williams, Grace Fox (seated), and Henry Cloud.

The fear of slavery was still deep in the hearts of some former slaves who deemed Fort Wayne to not be far enough north, and they headed for Canada. The departure was so widespread that by 1870, there were only 42 blacks in Fort Wayne. However, by 1900 the number was back up to 276. During that time, the oldest African American church was founded in Fort Wayne, the Turner Chapel A.M.E. Church. The church had its official start in 1869, but a land purchase for it had been made as early as 1849 (see Chapter Three).

Fort Wayne was not without its black celebrities of sorts. Two notables of the late 19th and early 20th centuries were Samuel Morris and William Warfield. Samuel Morris was a native of Liberia, West Africa. Enslaved in his home country, Morris escaped to work on a plantation in Liberia. He heard a missionary speak there, who was a Fort Wayne native known only as Miss Knolls. She taught Morris more than religion—she taught him how to read and write. Morris himself became a missionary, and soon his fellow missionaries recognized his passion for his work and gathered the necessary supplies and money to send him to the United States for an education. He ended up at Taylor University in Fort Wayne. The university was then called Fort Wayne Methodist Episcopal College, and Morris desired to study medicine to help his African brethren.

Morris spoke throughout the area and impressed audiences of all colors, but unfortunately, he did not have a chance to build a lengthy history in Fort Wayne or to return to Africa to help his people. Morris grew sick, probably due to the weather contrast between Fort Wayne and Liberia, and he died in Fort Wayne at the age of 20 in 1893. He was buried in Lindenwood Cemetery, and the Taylor University class of 1928 purchased his tombstone.

William Warfield was one of Fort Wayne's first successful black entrepreneurs (see Chapter Two). He was primarily a businessman and a music composer, and some of his music has been published. Warfield lived in a 21-room house on Douglas Street, and often opened his home to traveling black entertainers, dignitaries, and railroad workers because no hotel would allow them lodging. Warfield also earned money working for the Pennsylvania Railroad Shops.

There were still relatively few blacks in Fort Wayne at the turn of the century. In 1900, there were 276 blacks; by 1910 there were 600; and by 1920 there were more than 1,400 blacks in Fort Wayne. However, the period of 1913 until 1927 was a time of migration. Southern blacks came to Fort Wayne, and to all of Indiana, to work; 1920 was the beginning of an Industrial Era in Fort Wayne. Representatives of the Bass Foundry and Rolling Mill went south to recruit black workers for their factories. In 1922, the International Harvester came to Fort Wayne from Ohio, and it employed large numbers of blacks as well.

It is important to note that in Fort Wayne, although race relations continue to improve, the city has had its share of problems. The city's largest cemetery, Lindenwood, was originally quite segregated. Blacks were only buried in a section called "Garden of Peace." Mistakes did occur, however, because all bodies were assigned according to the funeral home from which they came. Anyone from Micheaux, and later in the 1950s from Ellis funeral home, automatically went to the black section. As a result, there were two errors: one white woman was buried with blacks, and one black man was buried with whites. The Dixie family was the first black family to have the benefit of mausoleum use in the cemetery, and that began in the 1930s.

The Northwest Ordinance (1787) prohibited slavery in Indiana, but blacks were still unwelcome. For almost one hundred years after the adoption of the Northwest Ordinance, a series of legislative items passed in Indiana, creating a more hostile environment for incoming blacks. The following is a timeline of some laws that hindered the progress of blacks in the state:

- 1812: Blacks were charged a $4 poll tax, but were not allowed to vote.
- 1816: Indiana became a state. The State Constitution opposed slavery, but white citizens were against black immigration. An Indiana state representative was the chairman of the committee designed to organize the sending of blacks to colonies in Africa.
- 1820: The fourth United States census was taken. The enumerator, a Mr. Abner Overman, reported that none of Fort Wayne's population was African American. All else that is known about Fort Wayne at this time contradicts Overman's findings. Obviously, blacks living in Fort Wayne were unaccounted for, and still others were counted and passed for either white or Native American.
- 1824: Indiana adopted the Fugitive Slave Act, declaring that it would not protect runaway slaves.
- 1831: Indiana State Representatives ruled that blacks had to provide certified proof of freedom and post a bond of $500 to $1,000 to guarantee good behavior.
- 1850: The black population reached a total of 82.
- 1851: The Indiana State Constitution was adopted. It forbade blacks from coming into the state, serving in the militia, testifying in court cases in which whites were a party, and attending public schools. (Incidentally, it was during this time that state funds partially financed a movement to send Indiana blacks to Liberia. Few blacks left. The ones who remained worked diligently to make Fort Wayne their own.)

Pictured are early members of the NAACP in Fort Wayne. They are, from left to right: Reverend Gilmartin of Unitarian House Church, Edith Kenirk, Mrs. Gilmartin, and Gladys Stewart. This photo dates to the 1940s.

The late 20th century found blacks still fighting racism in Fort Wayne. To protest racism in Fort Wayne Community Schools, Freedom Schools were started. The classes were held in churches or other community buildings, and black parents removed their children from Fort Wayne Community School classrooms. Spearheaded by pastors and concerned teachers and parents, the Freedom Schools were successful because the Indiana State School Superintendent placed financial sanctions against Fort Wayne Community Schools until the black students returned to class. The Freedom Schools were used for weeks in the late 1960s. Another little known fact about Fort Wayne is that interracial marriages were illegal until the 1970s. Most couples opted to go to Ohio.

Two

Early Fort Wayne Memories

It seems relevant to share facts about Fort Wayne, before and during the Depression Era. Most of the very poor did not use banks and were only affected by a lack of jobs. Some jobs paid well at all times. Musicians at the radio station WOWO were still making $90 a week. During the 1930s in Fort Wayne, some households still used outhouses, and a type of money called "script" was created. It was only good in Indiana, but it does not seem that its use was very widespread. In 1920, the population was 86,549; in 1927, it was 115,398. The black population was little more than one percent of the majority population. During the period from 1920 until 1930, the population of African Americans ranged from 1,452 to 2,360. In 1926, 40 blacks died in Fort Wayne, and 65 black children were born. The "Industrial Survey of Fort Wayne" does not specify the cause of death for these people, but only provides a list of various causes of deaths with the number of people who perished by those means.

During the 20s, vaudeville shows still played in local venues. Fort Wayne had two radio stations. The police station still had a horse-drawn wagon. A work week of more than 40 hours was common. In 1926, the average pay was $27.50 per week for men, and $16.80 for women. By the following year, the amount slipped 5¢ for men and went up 10¢ for women. Only 23.3 percent of the population rented homes—the rest were homeowners. There were 35,000 automobiles in Allen County as of 1927. Fort Wayne had 11 banks before 1933—by 1933 seven had been devastated by the Depression.

During the Depression, Fort Wayne attracted transients who were looking for work, food, and shelter. Perhaps attracted to Fort Wayne's railroads, transients arrived nearly in droves. They were greeted with hostility from Fort Wayne natives who were unemployed. As a result of the hostility, there was a riot in 1931 which involved three hundred people.

(Some of the pictures in this section are provided by Dorothy Dixie, who married Reverend John Dixie Jr. in the 1950s.)

The following are oral histories that have been collected by either the author or by individuals in the African-American Historical Society of Fort Wayne in the late 1980s. The latter have been transcribed by the author. Other histories have been derived from diaries left by early Fort Wayne residents. The complete diaries of Louise Woods and William Warfield extend into the 1930s.

William H. Edwards Sr., age 72.5 years.
Twelve or thirteen, October 1923, we moved here. That is the family moved here, when the International Harvester moved to Fort Wayne. My father worked at the International Harvester. We came here from the city of Akron, Ohio. When my father moved here, he was foreman of the heat treat department. I was a small boy, and I didn't pay any attention to where, or who he worked for.

Very badly, I would say, as they used to say, Fort Wayne's nickname was "little Mississippi," because the blacks were treated in Fort Wayne the same as they were in Mississippi. That's why they called it "Little Mississippi." You don't know how it was in Mississippi? If my wife and I were downtown shopping, doing our weekly shopping, and it was hot, July or August, and we become thirsty, and we wanted a soft drink, say preferably a lemonade. And we decided we wanted to go to a drugstore, preferably a Meyer's drugstore. They were practically on every corner, every block that is. We would start, we wouldn't get there, mind you, we would start toward the soda fountain counter, the manager would start shaking his head, "No, no, no." And if you didn't understand what he meant, he would come right out and say, "We don't serve colored people in here."

One thing about Fort Wayne, they had mixed schools. I came from Ohio with mixed schools and came to Fort Wayne where they had mixed schools. I went to school in Fort Wayne, at a school called Clay, on the corner of Washington and Clay. I was in the eighth, I mean sixth grade, I'm sorry. Sixth grade, I went to Clay School about half a year and from there transferred to Harmar School. That was called then Junior High School. I went to Harmar School seventh and eighth grades. I graduated from Harmar School and entered Central High School. I think that was in 1928. I went to Central High School. No, there was no mixed social life in Fort Wayne. The blacks had their social life together and the whites had their social life together.

When I came here, working conditions for blacks was very, very poor. The best they could get here was shining shoes. Very poor wages—seven, eight dollars a week. Shortly, one had a family and made fifteen dollars a week tops, for blacks. And what they called porter in the department store downtown, that was the size of the working in Fort Wayne for blacks. When we came to Fort Wayne, my father had a better type job. He was a foreman of heat treat at the International Harvester, and there was several blacks that came here, that had good jobs, good paying jobs, and they were looked upon as higher-class blacks. When my father and these other men came to Fort Wayne working for the International Harvester, they were in the hundred dollar bracket, uh, clarifying that, they were making a hundred dollars a week, or more. There wasn't very many blacks here when I came. And their pattern was very segregated. The housing pattern was very segregated. They lived on, I forget the name, they were all bunched together. Westfield was a group, Weisser was a group, and the west side of Harrison Street. I can't think of the others, I don't recall. And that was about the way the housing pattern was, grouped together. And we weren't allowed to rent, let alone buy, any place else. There was a later became my grandfather-in-law, Nathaniel Blanks, when he came here, where he lived on was then Helen Street, later became Dalman Ave., was in the country! And he had a little place out here and raised a few cows and grew a little garden patch out here. That's about the size of it.

The churches, there were two that I can remember, churches when I came here. The CME, the AME, I mean, excuse me, commonly called the Methodist church, and Mount Olive Church, which they called the Baptist church. The two churches, they called one the

Methodist and the other the Baptist church. There were several smaller churches, I don't recall their names at present.

[There was the] organization called Wheatley Social Center. Phyllis Wheatley Social Center. All the blacks had to meet there. The two organizations that I know of, the Elks and the Masons, had a hall. The Masons and the Elks [was] on Layfayette Street, and the Wheatley Center was on Douglas Street. What used to be, I don't remember. Most of the fraternity brothers were members of the first black boy scout troop in Fort Wayne. That was organized at Wheatley Center, and most everything that pertained to blacks was organized at the Wheatley Center. Yes, we had a boy scout troop. I had two brothers, Charles and Samuel, and myself, William, were among the first organized in the black Boy Scouts of America, that was in 1924. When organized we had 15 or 17 members I would say. The ages of the members of the scouts was between 12 and 17. Later on, we become young men. We organized a fraternity, a high school, and college fraternity at the Wheatley Center. There was such young men in there as Nathaniel B., John Ridley, William Edwards, Al Jennings, Willie Wilson, Willie Sweat, and so on. And, uh, we had one of the best programs for the young people. We had a Vespers Dance that we put on on New Year's Eve. And on New Year's we would dance and sing vespers until noon on New Year's Day. All the blacks in Fort Wayne looked forward to the big event. It was a good time had by all. Those days could...come back again.

There was an orchestra here. Josephine Gains, Henry Cloud, George Gains, those were members of Harmar School and Central High school orchestra. Mrs. Sarah Jordan, her husband was the minister of the Baptist Church, she led the orchestra. Later on, they had the band. The professional people we had were few. We had W.L. Briggs, the attorney. We had Ellis Micheaux, mortician. We had Dr. John Henry Littleton. That was the extent of the professional people here. The people here were basically working-class people and they didn't support the black businesses too good. Business people just wouldn't stop here.

Yes, we had quite a few black athletes and that's what they were known as, black athletes. Baseball players, basketball players, football players, and track stars. John Ridley was the first of this younger black generation, I'll put it that way, he played baseball at Central High School. Later, there was Mitchell Lyons, he was a four-letterman. And Nathaniel B., Al Jennings was also a four-letterman. Willie Woodson played football, and he said that was enough, Willie never played anymore. Lan Jenkins, he was letterman. From there, that was the beginning of the black athletes at the high school level. There was a young fellow by the name of William Edwards that didn't make high school athletics. He just couldn't be outdone. All the fellows he knew and associated with were big time black athletes. He just wasn't going to be outdone, William become the first Golden Glove to win a bout, that is a fight, in Chicago, Golden Gloves, *Chicago Tribune* tournament of champions. He went on to become pretty well known in boxing circles in the Midwest.

There were two businesses that thrived pretty well. One is still in business, the other was known as Carl Wilson's Chicken Shack. And, uh, let's see, he [Carl Wilson] also had an extermination business, after he died the business folded. Let's see, Micheaux, mortician, mortuary, is thriving. His wife is still running the business and it's thriving.

Majorie Wickliffe

I was born December 26, 1895. I was born here. I've been here all my life, I've never lived anyplace else. I went to Harmar School; stayed there until the eighth b[?] then went to Clay School for eight A, then went to Fort Wayne High School on East Wayne Street. I stayed there until the new school was built on Barr and Lewis Streets. That was Central High School. There wasn't very many blacks.

Clay School was located at the corner of Clay and East Washington. There wasn't very many [blacks]. There was five of the Dickersons was there, and four from Eliza Street, that was Mr. and Mrs. Bassett's children: Jane, Frank, and a brother that came here after he was raised in Kokomo, Indiana by his auntie.

I'm the sixth daughter of Andrew Franklin and Melissa Allen Dickerson. Yes, [I have siblings still living]. My older sister is Mrs. Fanny Wallace, at 1006 Eliza Street, my next sister is Mrs. Lillian Henderson, at 421 E. Douglas Street, and my younger sister is Naomi Doran, and she lives in the home at 1210 E. Berry. The home was purchased in June of 1895, just six months after I was born. [The name of the street had been Erie.] The name changed about 40 years ago, or maybe a little longer, I'm not for sure about that. There was a place at the corner of Francis and Erie Street, that the Nickel Plate Railroad had a big curve in there, and the city planners and engineers decided to cut Erie Street all the way through to Clay Street, which would take out the big loop in the Nickel Plate Railroad and join it with East Berry. And instead of calling it Erie Street all the way through to Rockhill, they called it East Berry. So it's East Berry from Anthony Boulevard, which was, years ago was Glasgow Avenue, to Rockhill Street. It went straight through the city. It's still intact [the house at 1210 E. Berry]. My youngest sister and her son still live there. It's the only house she's ever lived in and she's over seventy years old. Well, I just feel like I'm going home [when I pass there], because I've grown up there and didn't leave to live anywhere else until I got married.

There wasn't too many [black people when I was growing up]. My mother and father were the first negroes to start to buy property on Erie Street. There wasn't any other negroes who bought property on Erie Street for 31 years.

Well, when he [Wickliffe's father] came here, he was from Weaver, Indiana, with his two sisters and his mother. His father was dead in service, in war. He was only ten years old. And at that time, they either emptied wastebaskets, or spittoons as they were called then. He went to work for Mr. E.K., a well-known newspaper man, and the paper was called *Fort Wayne News*. He was 21 years old, and Mr. Hackett called him by his name, Frankie, and said "It's time you got a job and made some money so you can take care of your family." So Mr. Hackett got him placed at the Western Newspaper Union, which was located on Washington Street, they moved later to Clinton Street. My father stayed there from age 21 until he passed: he was there 46 years. He was a shipping clerk, he didn't do no maintenance work, he worked right with the newspaper, help fold 'em, assemble 'em, and get 'em ready for the Newspaper Express to take them to the little surrounding counties. It was printed on one side and when they got to the little town, they would be printed on the other.

Most of 'em [blacks] did janitor work, like along Calhoun Street, almost all those places along Calhoun had janitors, they didn't call them maintenance, they just called them janitors.

Black women just did domestic work, like washing and cleaning. My mother, with so many children, she couldn't leave home to work, she did special work, for people that lived in the white apartments on Fairfield Avenue, the Piano Company, and the Barracks, which was very popular in Fort Wayne, she did the washing for them. Where she got the idea was she did linens so nicely that the people in the white apartments bragged about her and she was able to make a real nice financial income from washing fine linens.

There wasn't much else for them to do [black women] except domestic work and cook. Yes, and I saw that I did more than domestic work. I was rather self-educated. I went to Central High

School at night and worked at Wheatley Center. Took the opportunity to learn how to type and how to meet people and how to conduct meetings. Mr. E.J. Unthank was executive director of the Wheatley Center, gave me the opportunity to work with the newspaper, too. All the articles that came out that was of interest to the Negro, Mr. Unthank would have me clip them out and put them in a big book he had. I can't tell you where it is now—it was left in Wheatley Center. But when Mr. Unthank went to Philadelphia to live, he of course left everything there. The center moving around like it did, I don't imagine that they even have it. It was quite interesting, well, I was there at Wheatley Center 16 years. And in that length of time it was three books that I had gotten, but where they are now I couldn't tell you.

The high school was called Fort Wayne High School. I went to Fort Wayne High School until May of 1915. In the meantime, I had a brother who had been very sick for almost a year, and there was just so much money spent on him, through a German doctor, Dr. [?], that my mother said that was in May, and I was supposed to graduate in June, "We just don't have the money to get you ready for graduation." I was within a month or so of graduating when I had to quit school. I went two nights a week for six weeks at Central High School. [Mrs. Wickliffe attended night school to learn typing.] I could use it for my work at Wheatley Center—I was industrial secretary. It called for things like getting in touch with workers at different places, hotels, drugstores. I didn't want to [hand] write, I wanted to do it in a professional way and type it. And so I learned how to type very well, I didn't learn shorthand because I didn't work in an office that required that. Most of the time I was at Wheatley Center, I done my own typing.

Yes, [people sought work at Wheatley Center]. It was just trying to help people find places to work, but they, the Employment Office, downtown, they recognized the Employment Office downtown more so than the Wheatley Center. Although, when the government [?] appointed Chester Alden of South Bend to be his assistant to go around to the cities where Negroes had come from the South to find work, and try to open up the different industries to hire Negroes. Although Harvester brought them Negroes here, but the Wayne Pump Company, General Electric, Rolling Mill, which is now [?] Steel, didn't have Negroes. Only a Mr. John Molton would go south from Bass Foundry and, uh, Pennsylvania Shops and bring Negroes here. Bass Foundry was once the largest car wheel factory in the world—in the world. Pennsylvania Shops was the railroad.

Most blacks [who were brought here for work] lived out in Rolling Mill, what they call Westfield now, with their relatives, they lived with relatives. Or were roomers in different places. What my mother was doing, when Mr. Tapp built the [?] Street bridge, he went south and brought quite a few Negroes here, because he knew they were taught to do cement and brick work and that's what he needed them to do. By us living only two blocks from [the bridge] my mother set up a little plan where she served them their lunch. Then they would come by in the evening, about eight or ten of them, and have what they call dinner baskets, these little wicker baskets, and she would pack baskets for their dinner or whatever for the next day because there was nowhere for them to eat on the East End. No restaurants—they were too far from their jobs. I don't know why they didn't get white workers to the work. I don't imagine that white workers would want to do that kind of work, I don't imagine.

The pay as far as I know was the same. The ones that my mother fixed lunch for and dealt with seemed pleased with what they were getting and it was more than what they got in the South. She only charged 75¢ or a $1. She would have sandwiches and homemade cookies, stuff like that.

Just before World War II, Mr. Hiney decided to put Negro girls in his drugstore at the soda fountain. These girls didn't know anything about working on a soda fountain or [how to work in] a drugstore. So Mr. Unthank set up classes that he asked me to teach [for girls like this] on how to act, how to dress, and also how to work a soda fountain. First young woman I hired to go down to see Mr. Hiney was Iva Mae Russell. She was the first black to work on the soda fountain. Soda fountain work was very unusual for black people. After the start of World War II, I was kind of discouraged because the black people we had placed [in jobs] at [drugstores,

department stores, and hotels] went to work for General Electric, and Wayne Pump, places like that because they paid more money.

Josephine Williams

My name is Josephine Gaines Williams. I was born in Fort Wayne in 1914. Lived here all my life. I had a very pleasant and happy childhood growing up here in Fort Wayne. I attended Clay School and Harmar Central [High School] where I had to leave school quite soon because of ill health. Very pleasant. We had our own program and cultural and things and we just sort of did our own thing.

I can't say how many black people lived here at that time. There was such a few here that I can say that everybody knew everybody. You were on speaking terms with everybody. Classrooms probably had 30 children in the class, but only three or four blacks in the class. Teachers were very nice, they worked well with us. I did pretty good [in school].

My father worked at Wolf and DeSaurrs as a janitor. Then, I think, a Dodge shop in later years. I just can't remember really, where all he worked. In the later years, he was in the WPA and that sort of thing. No, my mother did not work outside the home, she was always home. When I was quite young, I remember she worked at Robinson Park. She was the only black woman employed out there. Robinson Park was a not as extensive as Triers, but you got on a streetcar and just went out in the park and maybe packed a lunch and ate it out there and enjoyed yourself. They had concession stands and she was, if I remember correctly, that's what she [Williams's mother] was in. But I know she was the only colored woman employed out there. No rides, just a place to go out and enjoy yourself. They used to have parades and things for kids, used to gather them all up and take them out there. I remember being in one of the little white-dress parades. It's really funny—my mother had me all dressed up, the white dress, the big bow on my head, and some lady said "Oh my goodness, what a beautiful little foreign child," and my mother said, "Foreign child nothing! That's MY child!" Knowing my mother, you could just about hear her say that.

Yes, when we got a little older, at the Phyllis Wheatley Center, where Ms. Ulsup was the Girls' Work Secretary, we became Girl Reserves. That was really a highlight in our lives to have this Girls' Reserves Club. We just met and had little entertainments for ourselves. It was like a little social club. It did give us something to do. We went on hikes, went on trips, we went to Fox Lake to camp. We just had a real good time.

I remember when I was quite young, there was a Mrs. Williams, an attorney Williams's wife, over at Old Turner Chapel, and she was good about teaching us drama and plays and all that kind of thing. And we had a Japanese Butterfly Wedding and we all had on little kimonos that our parents, our mothers, made for us. And we were all decked out in these things. Just a lot of plays [and other things like] Tom Thumb Weddings and Womanless Weddings were always funny, because there was never a woman in it. The bride was always a man. I remember one year my husband was a bride and he had on my wedding dress! We were in our own little world and didn't worry about going into anybody else's.

Lillian Jones Brown Culture Club was a stem from the Girls' Reserves, because we couldn't be a Girls' Reserve when we got married. So I asked Ms. Ulsup if she would organize a club for young women. And that she did. They already had several other clubs, but the women were older than we were. They had the Industrial Girls' Club, the Mother's Club, at Phyllis Wheatley Center there was really something going all the time. That was the hub. Even when it was on Douglas and then on Hanna [Streets]. We used to have movies and all that sort of thing.

We had a lot of restaurants on Lafayette and Douglas, we called it [that area] the, oh, what was it? The Avenue, that's exactly what it was. I remember when I was quite small, Missouri Basie had a cafe, the Blue Goose Cafe, which was run by Ms. Wickliffe, and Mr. Saint Charles had a restaurant and Burie [?] Thompson had a restaurant, Leo Manuals, Mrs. Hamilton had an eat shop, Bob Stewart had an eat shop. This was quite a step up in the world, because in there, they served with white tablecloths on the tables. Henry Collins had an All-Nations Cafe, he called it. Where you could buy hot dogs and all like that. The Lucky Heart and the Little Castle,

and then of course, Mr. Roach with the barbeque. Art Hall on the other side of town with the barbeques and [?]. At one time it [Mr. Roach's barbeque shack] was next to Union Baptist Church, then it was on Douglas [Street]. White folks would come into the community to get his barbeque. He was famous for his barbeque.

Yes [there were other black businesses], we had pool rooms, shops. Monte Curry had a pool room and Bob Stewart had a smoke shop. Hops and scratches, and at one time we had Roadhouse, way out on the edge of town, run by Mr. and Mrs. Burrell Dyer. Then the Dixiana, the Dixiana came along later. I can't remember whether Mrs. Terry was the head of that or not, uh, it had a miniature golf course that was upstairs on Calhoun and Douglas. That was around in the '30s. They used to have dances down to the Pennsylvania Hall, I think that was on Harrison, upstairs. [There were] no integrated activities at that time.

Most all of it was domestic work in the home [that women did]. In the early days, women weren't in the factories. Yes, [hauling and dry cleaning was done by blacks]. Kimble Black had a dry cleaning establishment, then um, oh what is that—Lillian Henderson's husband, and, she belongs to our church, her husband just died, Betty Wallace. Her husband had a hat place. Then at one time, Jessica Anderson and her husband, Irvin, had a shop, a dress shop, and sold dry goods. This was all in the black neighborhoods.

Turner, Union, Pilgrim, and later came Shiloh and the Church of God in Christ and then the Church of God, then numerous Baptist Churches sprung up. Elder Boone established the Church of God in Christ.

Well, it was in the paper [Williams' wedding]. It was the second. Leo Manual and his wife had the first wedding at Turner Chapel. Several years later, why, Beauf and I married. It was funny, they had it next to the classifieds, down in the corner, but they had my picture. It was a real nice wedding, at least I thought, but then I was on cloud nine. We had a reception at the hall owned by Mr. and Mrs. Alexander, they were friends of my husband. Mrs. Wickliffe catered the reception. It was the first wedding she had ever catered and then she just took off! In the paper, there was a title above it in colored circles. It said "Approaching wedding of December," then my picture by the Herman's studio. That was in the back of the paper.

Well, I had no special training [for speaking and writing]. I think I owe all of it to my dad. When I was a little child, Dad would quote poetry to me. And then my mom would too. I grew just loving poetry. At Harmar School there was a teacher, Kathleen Harsig [?], she was just a wonderful teacher. And she was my literature teacher. I'll never forget, she was really hard on you. When you wrote that poetry down, you had to have that punctuation correct. I owe, I think, a lot of it to her. I thought of her many times [over the years]. She was just a wonderful teacher. Education is important. She was an older woman at the time she was teaching school, but she was thorough. I received very good training under her. That was in fifth or sixth grade that she taught me, and it stayed with me all through the years. Harmar was like a junior high, that's what they called it.

[As a young adult] I worked at the [?], it was called the Anthony then. At first, I started waiting tables, then the men were going to war, I became the banquet hostess. I was in charge of hiring help for the banquets. Most of the help was black, when we couldn't get it, the [white] girls from the coffee shop would come in and help out. That was always a pleasant encounter. We had no problems with them when we worked together. I worked there about 23 years. My husband was employed at the International Harvester. I had two children. Well, [one son] started singing in church, as most of our black singers do. Mrs. Naomi Phillips asked him to sing a solo one day, and he sang. And from then on he started singing. At Zollner [stadium] he sang the Star-Spangled Banner. Mr. Van Arman, the late Mr. Van Arman, heard him sing and asked one of his friends, Mr. Hal Monroe, who was with the Associated Music Company, I may not be correct with the title, he [Mr. Arman] asked him [Mr. Monroe] to hear him. [Mr. Monroe] heard him, and Mr. Van Arman said "You'll never have to worry about your son being unemployed." And he goes from gig to gig. He's been singing professionally ever since he left the army.

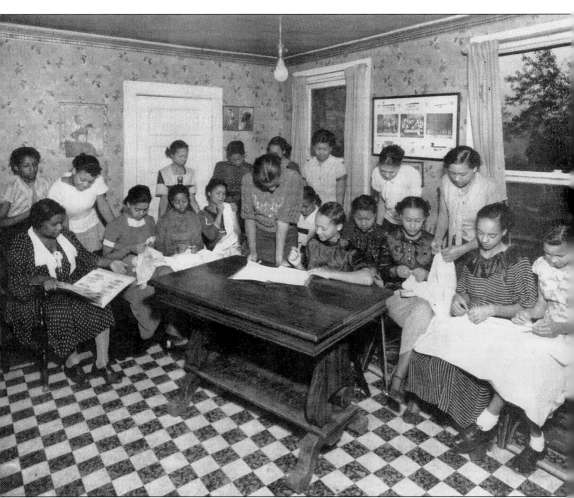
Elma Alsup, director of programs at the Wheatley Center, is shown here with a group of young ladies at the Recreational and Cultural Center in 1936.

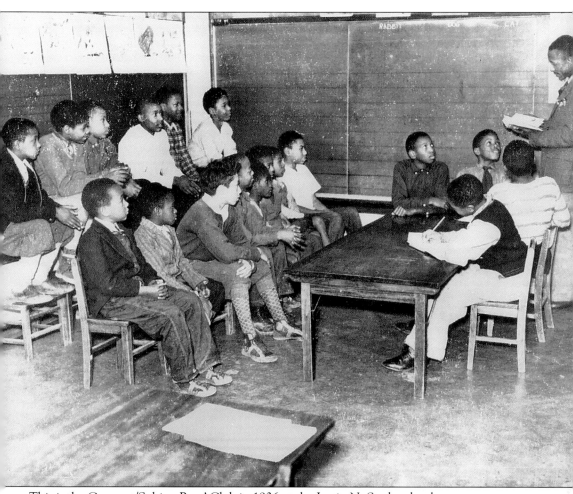
This is the Crescent/Sphinx Boys' Club in 1936 at the Justin N. Study school.

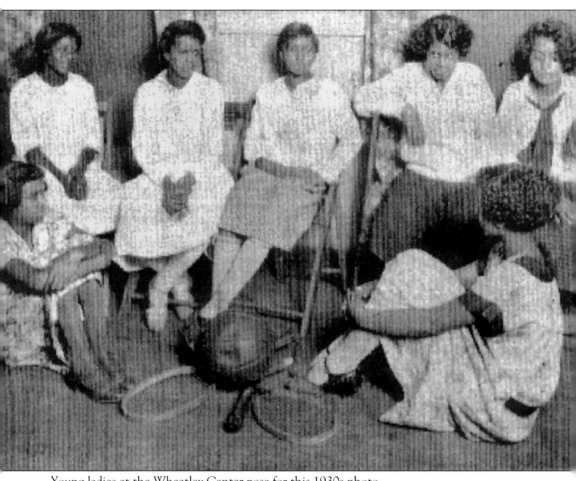
Young ladies at the Wheatley Center pose for this 1930s photo.

William Warfield

William Warfield came to Fort Wayne around 1894 and was Fort Wayne's most prominent black citizen. He was college-educated, and an early entrepreneur. Mr. Warfield owned real estate throughout the city, including a 21-room, three-story rooming house in the 400 block of East Douglas Street. The home served as his residence as well. He opened his home to black dignitaries and entertainers who visited Fort Wayne, because blacks were not permitted to lodge in any local hotels.

Mr. Warfield was a musician and songwriter. He wrote a song honoring Fort Wayne in 1930. A number of his songs are registered with the Library of Congress. He was an early writer in local black newspapers. He kept a volume of diaries for 30 years, in which he recorded all major Fort Wayne events.

William Warfield was considered to be a learned man and a gentleman, who was well respected in the city. A street in Fort Wayne was named after him.

From "Life and Times of William Eli Warfield" 1909.

Fri. 1 January 1909: When the bells and the whistles were ushering in the New Year, I was busy working at the Elks Temple which was being dedicated. We all spent a very happy new year. Mrs. Clark and her niece Pearl Ramsey, remained and will go home tomorrow.

Pearl and Olie Clay attended a social at the A.M.E. Church this evening. Pearl seems rather reluctant about going home and has not heeded Mrs. Clark's appeal for the last two days to go home with her. Mrs. Clark is not so well, she weighs 260 lbs.

Sat. 2, January 1909: Jim Wright called by phone telling me to come by the Home [?] Billard Hall and get my money due for services at the Elks Temple. Mrs. Clark and Pearl Ramsey left at 12:20 today for home in Delphos O[Ohio]. Mrs. Ramsey, Willie and I went to the train with them. Velma cried to go. Mrs. Clarks' little dog, Cricket, did not like being put into a box so he whined too.

Mrs. John Green is the mother of a new baby boy. Mr. Green came over to telephone the doctor. Mrs. Wright called this morning.

Sunday 3, January 1909: My wife went over to see Mrs. Green and the baby this morning and found things in such a shape that she immediately began cleaning up. She said she got a dish pan of dirt out of two rooms. The neighbors are spending [?] their time with the Green family as they are in needy circumstances.

I put on my Christmas slippers for the first time and wore them, they are indeed a worthy and most acceptable gift. My wife could not have given me a nicer or more desirable present.

Monday 4, January 1909: Mr. Goodman called me this morning by phone, to come down and clean a flat that he had rented to Mrs. Ray Confare. I went down at 9:30 o'clock and returned home about 4:30.

Tuesday 5, Jan. 1909: Mr. Goodman had me come down again today and assist a man in mixing cement for a wall. The wall was to prevent water from flowing in the cellar of Arnold Plumbing shop. I found the job of mixing and carrying the mortor a hard one and it soon had me sweating freely.

Jim Wright came over and jollied me awhile. I paid my water rent also my telephone rent today. Another colored man and myself put in a ton of hard coal for Mr. Goodman. Mrs. Beadell gave birth to a boy this evening. Harry Underwood works for the Beadells.

Wednesday 6, Jan. 1909: I got home from my work a little earlier than usual this morning and took home Brinsley [?] washing. It did not dry yesterday, hence I had wait till this morning. I found the old man hitching up his oil wagon and he paid me.

Dr. McKeeman called me today but I was sleeping. He wants me to clean his office tomorrow. The coldest weather of the present winter came tonight—8 degrees above zero.

Thursday 7, Jan. 1909: I cleaned Dr. McKeemans' office this morning. I made a big fire and when he came down, he found things in good shape and his office comfortable. I left before he came. It took me from eight o'clock till one o'clock to clean up for him. It was a cold morning. I took pint [?] water from home and heated water on his stove also.

Mr. Brown had some old linoleum hauled today and the man threw it in yard by mistake. I thought Harry had thrown off in our yard and I took charge. I learned later that it was not mine.

Friday 8, January 1909: Mr. Goldstine called by phone and had me meet him on corner of Calhoun and Holman Sts. and from there we went over on Lafayette St. to look at a house he had there for sale. It was a bargain at [$]2,200 but the location is bad—being in close proximity to the Pennsylvania shops and gets much smoke. Se we let this place go by too.

Saturday 9, January 1909: Got coal. I finished my work early this morning at Colonial Billard Academy and when done at the Winde [?] block, I did my marketing and proceeded homeward. When done eating breakfast, I took shortly afterward a nap of two and a half hours.

When it was twelve o'clock I dressed and went down to do my usual work for Mr. Goodman. I also assisted him in making a preparation for a trip (next Saturday) to Florida and Cuba. I helped him get out his trunks and transfer the things there in. He opened his heart and gave me a light colored overcoat.

Sunday 10, January 1909: This has been a dreary drizzly day, being especially dark and cloudy. I remained in all day, read the *Journal Gazette* and the *Cincinnati Enquirer*. I devoted much time to reading accounts of Jack Johnson and Jim Jeffries who are occupying most attention in pugilistic circles. Many think these gladiators will meet in the near future to decide heavy weight championship of the world.

Monday 11, January 1909: I paid Mr. Rosenwinkle my insurance today on our barn and residence. He offered me two propositions that he claimed were money makers but I did not take him up.

I called Mr. Stephenson [?] (the furrier) today and looked for him to refuse to me his house but to my surprise, he offered it to me, but I did not see how I could make much by paying him $45.00 per mo.

I also went to Hanna St. to see a house for sale. I found it too close to the railroad though it is a bargain. Harry did not come to his meals today.

Tuesday 12, January 1909: Mr. McKeeman called by an agent from an Illinois Nursery called and exhibited his samples today. My wife was washing and hated very much to stop. We did not give him an order and he remained so long, we were glad to see him go. (A Mr. Schellenberger).
This morning the ground is covered with a deep snow and the weather is exceedingly cold. Rev. Pettiford called and talked over plans he has for building a new church. He received $150.00 subscription today Messers [?] Yarnelle and Hackett were the donors.

Wednesday 13, 1909: Dr. McKeeman had me make him a fire and cut him a lot of kindling wood today. It took me nearly three hours to do the work and I got pretty cold at times.

Mr. Goldstine came up to sell me the new Queen Restaurant (price $1800.00). I promised I would look through the place and consider the matter, but I think it too much for the outfit and

will not buy at that figure.

Sherman Sweede and wife surprised us by calling this afternoon. They have been visiting in Michigan and Indiana.

Thursday 14, January 1909: I remained at home all day. I started to market and my wife said we had a good supply in the house, so I did not go.

Things are very high at present: fresh eggs are 33 cents a dozen and the best butter 38. I am glad I am working these hard times and that I have an emergency dollar laid up.

I have been thinking of the restaurant deal today and if it looks good to me I may buy, but he must come down from $1800.00.

Friday 15, January 1909: This afternoon Mr. Goldstine called for me and we went to see Mr. Dickersons restaurant. I looked through and made up my mind what it was worth and told him would call again. The place offers a good opportunity and if I can get him at my price, I will take him up.

Mr. Goodman called me by phone and requested me to come down in the morning for a talk and/on what he wanted me to do while he is absent.

Saturday 16, January 1909: (My pay day) Mr. Goodman paid me before going on his southern trip. He left at 1:25 p.m. over the R&I road. He and his wife are headed for Florida and Cuba. Before going he gave me a coat and vest and a good Dunlap hat. He is said to be very tight fisted but he is opening his heart to me here of late.

Mrs. Myrtle Lacklin Bowles became the mother of a boy baby tonight late. Mrs. Clay called this eve.

Sunday 17, January 1909: Today is pretty cold. I was late getting to my work at the Beverforden drug store this morning.

My wife and I left the children with her sister, Mrs. Ramsey and this afternoon went to see several houses for sale. We had a long walk and enjoyed our outing. We did not get to see Mr. Dickerson, the restaurant man. We met the furrier and he had just turned over the key of one house that we had hoped to see. The children acted very well during our absence.

Monday 18, 1909: I was over to see the restaurant man this afternoon. I made him an offer of just what I think his place (out fit) is worth ($600.00) cash. He refused and I politely told him good-bye. I had a talk with three real estate men (Curdes, Ashley and Vesey) and looked at a few houses for sale. On coming home I made up my mind to go slow and wait for a better opportunity.

Tuesday 19, January 1909: Got my money from Colonial Billard Academy today, and owing to dull business, I suppose this will be my last month at $35.00. Mr. Porter, my boss, after a nice little talk asked me to put in half time and I accepted $20.00 per month until business picked up: but I think there is little or no likelihood of increased business. So I think my cut in wages is permanent. I considered readily, having no other alternative.

My wife and I hated the reduction very much but as usual she said something will turn up. The Lord will provide.

Wednesday 20, January 1909: Mr. Goldstine and I looked through and partially ___ the Graham restaurant today. We ____$450.00 and he wants $1750 for the location. I offered him $500.00 partially in good faith to see how it struck him, but he refused it, though I think he was tickled to think of the prospects of getting so much.

I took down and cleaned Dr. McKeeman's office stove pipe yesterday. Called on Mr. Ashley, the real estate man, but found him out. I wrote a card to Pearl Ramsey for her mother.

Thursday 21, January 1909: I met Mr. T.Y. Gross today by appointment, and bought a nice range and ice box and table for $43.00. The range is an excellent one, having originally cost $105.00 and the cost of the refrigerator new was $75.00 hence with the table thrown in, I think I got a great bargain. My wife's sister, Louisa Ramsey, left at 12:25 today for Lima, O[hio]. I went to the train with her and paid her fare (1.30) and gave her $1.00 additional.

Friday 22, January 1909: Had my ice box and range hauled today and although I assisted the men, we had a hard time of it. I had to tear down part of my coal bin to get the things in the barn. The charge was $2.50 [?] and I gave the men 50 cents for the heavy work.

The hard rain made things worse today. Our has been visited today by different people and this evening my wife is almost sick over the days strain. I paid my insurance (life) $48.52.

C.A. Graham, the restaurant man, called today and remained here about three hours, trying to get me to buy his restaurant and remaining house. Mr. Beeves (?) called today while I was absent and asked my wife if we wanted to sell our house. He said someone wanted it as a rental investment. We think (almost know) he is interceding for the Wabash Railroad. He wanted to know our very lowest price.

Saturday 23, January 1909: I went on market this morning for the first time in several weeks. I only bought a pound of butter. This afternoon I did my usual work at the Goodman flat and wound up at five o'clock.

Mr. Graham called by phone and in person today and is still urging me to buy his rooming house. On coming home this evening he called me again by phone and I discerned, he was a bit angry because I was not jumping at his offer, but I am determined that he shall not cheat me.

Sunday 24, January 1909: Today has been very quiet and no one has called. Mrs. Ramsey's absence makes quite a change in general. This was our first Sunday alone in four weeks and I must say we enjoyed it greatly.

Monday 25, January 1909: Mr. Goldstine and Mr. Rosenwinkle insisted on my buying the New Queen Restaurant today and offered it to me at practically my price, but when I think of the high rent etc. I see only one sensible thing to do and that is to let it go by.

Lewis Abbot called this evening and collected class dues. He remained a long time talking and when he saw that I was nodding, he took his departure. I was glad to see him go.

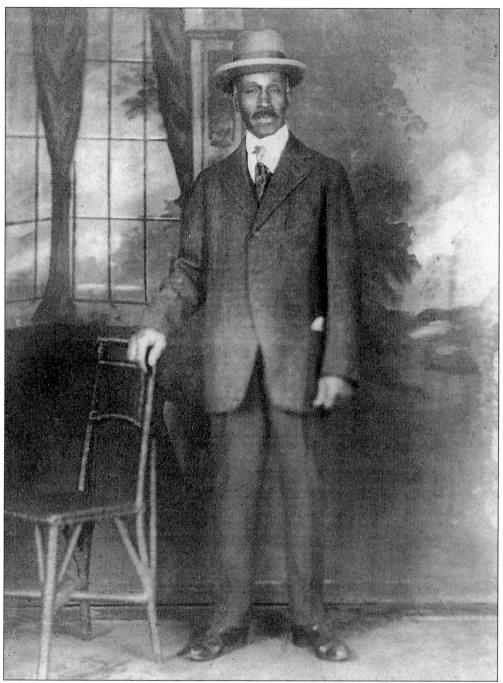
This 1911 photograph shows William Warfield.

Louise Woods

Louise Woods is the great-grandmother of Dr. Miles S. Edwards, who helped greatly with this book. The following excerpt is from Woods's newlywed days in 1911.

Monday, Sept. 18th—rainy: got breakfast, It was raining so slept. Mr. [?] came; after supper hubby and I went to town bought some stamps, did not go to "Mite Society" came back home went to bed. Mrs. Todd met Delegates at her church. Everything O.K.

Tuesday, Sept. 19th—fair: Married three weeks today. Washed bright day to dry clothes. Myrle Moten Married two years and one month today. After supper hubby went to help remove ashes from his church, and I went to the Wiley M.E. church to hear the elocutionist Miss Elnora Gaskins bought cream for me and also Mrs. Todd. Got home hubby was in bed all O.K. next morning.

Wed., Sept. 20th—got breakfast slept did not go to prayer meeting absolutely nothing doing. Cramps from hold urine all night. Fair.

Thurs. Sept 21st—fair got breakfast slept. After supper went to hear Rev. Reed preach, also Mrs. Strong from South America, back home, bed business picked up both night and following morning all O.K.

Friday, Sept. 22nd—fair, Emancipation day got breakfast 15 min. past 5 when I rose went to Grace's—forgot to put spoon in hubby's basket. Mrs. Todd went fishing. After supper talked of love affairs until nine o'clock—went to bed business O.K.

Saturday, Sept. 23rd—baked cake apple dumplings–hubby did not kiss me good bye–lemon and apple pie, went to market with Mrs. Todd, back home, washed dishes, bathed. We sat up and talked until hubby came home. Biz O.K. fair.

Sunday, Sept 24th—fried chicken made gravy. We did not go to church but slept instead. Got up at four o'clock eat dinner, dressed went to Mr. Wilson's from there to church. After church home to bed. Biz O.K. fair.

Monday, Sept. 25th—made team, wrote four leter to Emma's Hopson, Alsigh & mother and Alice Taylor, supper, Mite Society and to bed. All O.K. fair.

Tues., Sept. 26th—rainy: breakfast, took rained Mrs. Todd to Mr. Coleman. All O.K.

Wed., Sept. 27th—breakfast, threatening weather. Washed slept, went to prayer meeting, no meeting went to hear Billy Sunday. All O.K.

Thursday, Sept. 28th—cloudy hung up clothes ironed, hubby went to club, rained terrificily. All O.K.

Friday, Sept. 29th—Mrs. Todd went to hear Billy. Hubby wanted to go to church meeting but did not go went to bed. All O.K. fair, married 1 month.

Sunday, Aug. 25th—Fair-warm-hubby went to Van Wert, Ohio, I went to Sunday School. Hubby came home about 1 o'clock, all O.K. Rev. Burney came out about 3 o'clock with a new barber from Cincinnati—Mr. Smith.

Monday, Aug. 26th—Fair-cool-hubby went to the barber shop with the man, came back, he, baby & I went out to the Rolling Mills, came back through Swinney Park on home. Hubby went back up town, home to bed, all O.K.

Tuesday, Aug. 27th—Fair–cool—I washed, hubby went off, came back, ate, slept, did not eat supper, went off—papa quit the Foundry. Hubby came home to bed, all O.K.

Wednesday, Aug. 28th—Unsettled: hubby working on the Pennsylvania gang. I went to Sis Faye's, back home; hubby home, had supper, went off, left me sore at him, about the Masonic Concert, back home to bed, all O.K. See—4 quarrels to date.

Thursday, Aug. 29th—cloudy: This is Leslie's birthday (4 yrs.), Papa has gone to work at the Penn Freight House, I have been married over one year today, hubby did not go away after supper only up to Robert's, back home, to bed, nothing doing. Baby 12 weeks old today.

Friday, Aug. 30th—Fair-warm: I ironed & sis Faye came over. Hubby went to church meeting, came back, to bed, all O.K.

Saturday, Aug. 31st—Fair-warm: washed, went to town, bought baby cap & bibs, came home late. Hubby did not say good bye, brought home fish sandwiches. Nothing doing.

Sunday, Sept. 1st—Fair-warm: hubby went off to Baptist church, Josephine and I went to the Methodist, hubby brought home ice cream, didn't go to communion—we went to church, after church to Whorton's Restaurant, saw Pearl Green & Mrs. Ghee, around Calhoun by Mrs. Walter's hme, hubby went to meet Mr. Smith and family, came back to bed, nothing doing.

Monday, Sept.2nd—Fair-Labor's Day, papa worked, hubby home, went off don't say good bye any more. He & Henry came back, asked me to go with him & Mr. & Mrs. Smith to Robinson Park. We went to the Ridley Restaurant first, then to the park. While at the Res. My plume got caught in the electric fan; baby spoiled my dress in the park. We left the baby cart at the barber shop, came home on the car. After supper to all O.K. Saw H.T. at the shop.

Tuesday, Sept. 3rd—Fair: I went for buggy, Mrs. Smith gang all the men gone to work, no good byes now adays. Went off after supper, brought home some fruit, all O.K.

Wednesday, Sept. 4th—Fair-warm: went on business for hubby came back washed baby, went to sleep, hubby came home after 4 o'clock, he is carry hod now, he's in a little better humor, went off still fail to say good bye. Back home, to bed, nothing doing.

Thursday, Sept. 5th—Fair-warm: washed today, started to go into the park after supper, changed my mind. Hubby staid home, so hot. To bed, all O.K.

Friday, Sept. 6th—Fair-warm: too hot to iron, went up town with hubby after supper. Baby 8 months old today, back home to bed, nothing doing.

Saturday, Sept. 7th—Fair-warm: ironed. Hubby came home early, bathed, went off, no good bye, home after 12 o'clock, to bed all O.K.

Sunday, Sept. 8th—Fair-Warm: We (hubby & I) went to Baptist Sunday School, Methodist Church 11 o'clock services, Robt. Preached, from there to barber shop. Restaurant & Driving Park, back home, hubby-

Friday, Sept. 15th—job fair: breakfast/supper. Nothing doing. Whatever.

Saturday, Sept. 16th—baked rice pudding, veal roast and raisin pie, downtown with Mrs. Todd. Back home, bathed. Hubby home at 12 :15 business is O.K. fair.

Sunday, Sept. 17th—staid in bed late for church missed Sunday School entirely, after breakfast, church, after church home, slept, wrote letter to parents, after dinner went to J. Hughes stayed until time for B.Y.P.U. Met Mrs. Byrd, and J. Hughes wife and "Fox", went back home after Jacket then to church after church home. Bed business working—supper to bed all O.K.

Sat., Sept. 29th—fair: breakfasted, baked bread no good went to market with Mrs. Todd go $.25 worth of brains. Hubby brought chicken home, to bed nothing doing whatever.

Sunday, Oct. 1st—cloudy, brains, tea, sirup and fried cakes for breakfast, rained hubby went to church, I did not go. afternoon hubby went to sleep. I was not feeling very well fried chicken made gravy for dinner, Mrs. Todd came home could not get in the house forgot her key. Went to church at night communion services, back home to bed, all O.K.

Friday, Nov. 17th—Rainy: got breakfast, hubby always helps me, had pig's feet for breakfast, went to grocers—Rec'd two letters one to me and one to Mr. Woods from mother. Chicken made me spill my potatoes. This is a meeting night at church to arrange for Thanksgiving. It rained so hubby did not go neither did Mr. Freeman. Ethel went to stay with Mable. We went to bed. Half sore over contents of the letters, all O.K.

Saturday, Nov. 18th—Fair: got up at 5:30 got breakfast, wrote Ma a letter, Mr. Woods gave me $10 to buy his shoes and my hat with. My hat cost $7.00, his shoes $2.50 came back home on car ironed had supper, bathed and went to bed. All O.K.

Tuesday, Oct. 8th—Clear: hub off to Coleman's made me some supper to bed all O.K.

Wednesday, Oct. 9th—clear: hub got job to work afternoon, ordered coal 1 ton he had to pack it up stairs. Supper to bed all O.K.

Thursday, Oct. 10th—Clean: hub worked–washed–supper to bed nothing doing.

Friday, Oct. 11th—Threatening rain today hub working–supper to bed all O.K.

Saturday, Oct. 12th—Clear: hub in shop ironed–supper to bed nothing doing.

Sunday, Oct. 13th—hazy: Sun in eclipse–hub to church–no church on acct. of inflss. O.K. warm, fair.

Saturday, Oct. 26th—Threatening: hub worked half day in shop afternoon dinner supper to bed nothing doing. Henry birthday.

Sunday, Oct. 27th—Rained all day all day home. Ed Thomas up breakfast/dinner, supper—to bed all O.K. Papa 53 yesterday.

Monday, Oct. 28th—Unsettled: hub worked for dinner supper to bed nothing doing half sick.

Tuesday, Oct. 29th—Cloudy: hub worked. Tim by, dinner supper to bed, all O.K.

Sunday, April 20th—fair–cool. Hubby went to Paulding at 4:25. I went to Sunday School, back home. Mother went away to Mrs. Scott's, home after church. Hubby came home after three o'clock morning, to bed, all O.K.

Monday, April 21st—fair, warm. Hubby home all day, washed my head. We (he & I) went to town at night, back home to bed, all O.K.

Tuesday, April 22nd—fair, increasing cloudiness. Berta & I went to town. Hubby home when we got back. He went off, home again at 11:30, to bed, nothing doing.

Wednesday, April 23rd—fair–warm. Hubby & Papa home, hubby & I washed, planted flowers, went by Bass' foundry & Dora Elliot's, on home, to bed, all O.K.

Thursday, April 24th—fair–warm. Baked, mother went to Bloomingdale, hubby worked, Papa worked for Jenette Moten. Got supper, after supper to bed, all O.K.

Friday, April 25th—cool, cloudy. Went up among shines, back home, supper, to bed, nothing doing.

Saturday, April 26th—rainy. Washed, ironed , supper, bathed, to bed, all O.K. Rosa & Ruby out.

Sunday, April 27th—rainy. Hubby & I went to church by Shortie's & Smith's, on home, dinner. Joe More married today, to bed, all O.K. twice.

Monday, April 28th—rainy. Hubby not working, gone away, back at 4 o'clock, supper, to bed, all O.K.

Tuesday, April 29th—fair–warm. To drug store, took hair to Mrs. Lacklin's, back by Alberta's, on home. Supper, to bed, nothing doing. Married 1 yr. & 8 months.

Wednesday, April 30th—fair–warm. Washed, cooked supper, after suppper to bed, all O.K.

Thursday, May 1st—fair–warm. Sewed, got supper, to bed, all O.K.

Friday, May 2nd—fair–warm. Sewed all day, summer clothes. After supper hubby went to church meeting, back home, to bed, nothing doing. Baby & I went piece the way with Papa.

Saturday, May 3rd—washed, ironed, to town with Alberta, back home at 6 o'clock, supper, bathed, made baby's dress; bought a new hair net for him, went by the barber shop where hubby was, on home, to bed. Hubby came about 12:30, nothing doing.

Sunday, May 4th—fair. Everybody went to the Methodist Church for the K.P., sermon but there weren't any. Hubby, baby & me stayed for Sunday School, others went to the Baptist Church. We came home & went back to the Methodist, hubby preached "Transfiguration of Christ," we walked back home, by Shortie's, got ice cream, on home, to bed, all O.K.

Monday, May 5th—fair. Men working. Got supper, to bed, all O.K. twice. Mrs. Jameson and Alice here.

Tuesday, May 6th—fair, cool. Baby 11 months old, did nothing, got supper, after supper, to bed, all O.K.

Wednesday, May 7th—fair–cool. Did nothing, got supper, to store, back home, to bed after supper, all O.K.

Thursday, May 8th—fair. Washed, to town, back home, got supper, to bed, all O.K.

Friday, May 9th—cloudy–rainy. Mrs. Jameson down, ironed, after supper hubby & I went by barber shop on the Carnival , saw G.T., on home to bed, a good O.K.

Margaret Myrick and Delmus Wilcher

The following shortened oral histories were given by current Fort Wayne residents Margaret Myrick (90) and Delmus Wilcher (also 90).

Margaret Myrick

I've been in Fort Wayne since 1936. I was married in 1935. I was born in Alabama. After the Depression things were rough, I came because my husband's sister was here and he wanted to be near her. I didn't like it here at first because it was so prejudiced. Things were bad until the war. I was married for nine years when my husband [went to] serve in the war. He served in the war three years.

Phelps Dodge didn't want to hire us [blacks], but the government made them because the war was so bad. [Myrick went to work for General Electric.] I made good money there. We [blacks] used to get into arguments with white women who worked there. At Phelps Dodge they [management] told us not to let white women know how much we made, because it was equal to or more than theirs. I made coils for bomber planes at GE. I made $15 a week cleaning powder rooms in three theaters—the Palace, the Embassy, and the Paramount.

[At one business, Myrick was offered a position while her brown-skinned friend was told they had no positions for her.] And it was just because she was brown.

Fort Wayne is just as bad as Alabama. White passengers would let you know they didn't want to sit by you on the streetcar—they would get up and move. You could sit anywhere you wanted in theaters in Chicago, not in Fort Wayne. Blacks had to sit in the balcony at the Embassy Theatre, even when Cab Calloway came here.

We didn't do a lot of violence like nowadays. I have seen a lot of improvements [with racism], but still there's a lot [to be done]. It's three times better, but use a lot more changes.

Delmus Wilcher

I was born in Dublin, Georgia. I came here looking for work and I've been retired from International Harvester for 30 years. I have been a member of Turner Chapel A.M.E. Church for 64 years.

We knew to expect a certain amount of racism. You knew not to go to certain places unless you were looking for a fight and wanted to get in trouble. Just because the door is open doesn't mean you got to run through it.

Fort Wayne held its own pretty good during the Depression. Lot of white and colored people had hard times. I made $5 a day. I never got on poor relief. Found little piece of jobs until [Wilcher got] the Harvester job. A lot of young people [today] don't think the Depression happened. I served in the army: three years in the regular army, and two years in the airforce.

Young people don't realize how far we've come. Blacks used to be relegated to plant maintenance—sweeping the floor, cleaning machines, shop work. We knew from whence we came.

Margaret Myrick is shown here in the 1940s.

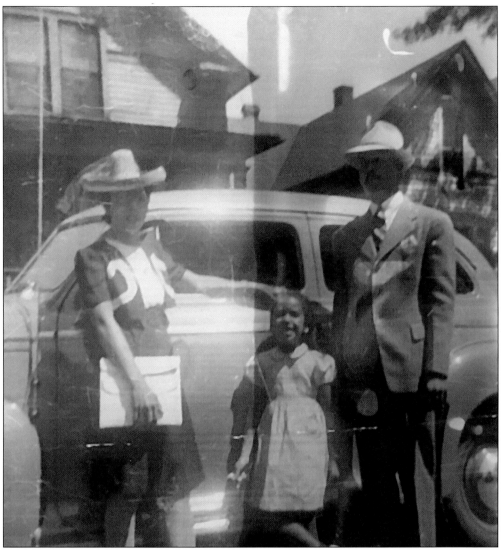
Pictured are Margaret Myrick, the unidentified daughter of a friend, and Warrell Myrick in the 1940s.

This photo of Laura (Margaret's sister), Margaret Myrick, and Warrell Myrick was taken in 1936.

Helen and Hazel ?, relatives of Dorothy Dixie, are pictured here in the early 1900s.

Warrell Myrick's great aunt and uncle, names unknown, are pictured here c. 1910.

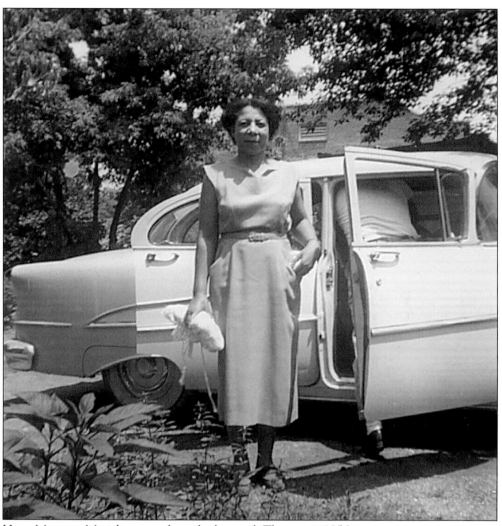
Here, Margaret Myrick returns from the hospital. The year is 1956.

This 1933 photo shows Warrell Myrick in his hometown of Chicago.

Here is the Elma Alsup Social Club in 1950.

Mr. Raspberry Thomas and his neighbor, Norwood Goldsly, are shown here in 1935 at 2326 Taylor Street.

This early 1960s shot shows Margaret Myrick.

Here are the Reverend V.S. Robinson and unidentified friend, c. 1930.

Cleveland "Captain" Patterson is shown here in the 1940s. Patterson is Margaret Myrick's brother.

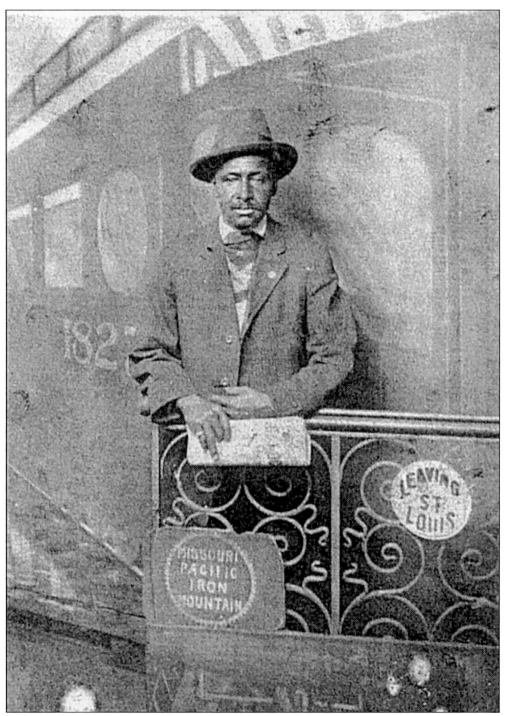
Fort Wayne native Jerry J. Johnson rides a train home in 1918.

Pictured are relatives of Margaret Myrick—Dot, Doris, Josephine, Inez Collins (her niece), and baby Brenda (last names of all except Inez unknown) at Fox Lake in 1938. Fox Lake, in Steuben County, was the only lake in northeast Indiana friendly to blacks.

This 1920s photo pictures Boy Scouts at the Wheatley Center.

Here, Margaret Myrick takes young Wanda Graham to Alabama to visit her father. Wanda's mother was in a Fort Wayne sanitarium.

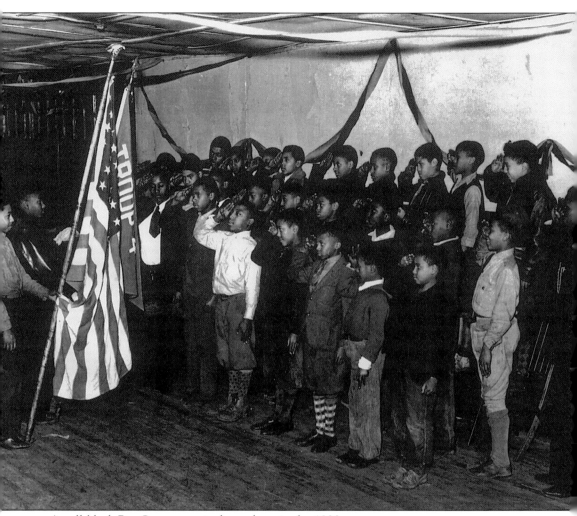
An all-black Boy Scout troop is shown here in the 1920s.

Clifton Myrick, Warrell's brother, is shown here in 1934 in their hometown of Chicago.

Helen Bass, second from the left, is shown here with her daughters.

This c. 1925 photo shows Helen (Bass) Dixie.

The Burnetts, neighbors of the Myricks, are pictured here in the 1920s. The Burnetts lived on Eliza Street.

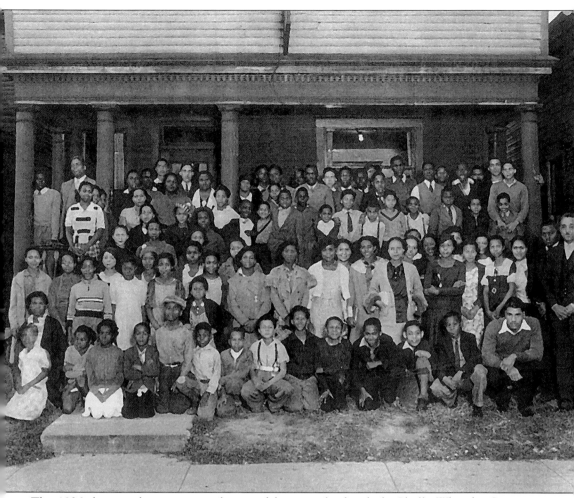
This 1936 photograph captures a gathering of those involved with the Phyllis Wheatley Center located at 421 East Douglas Street.

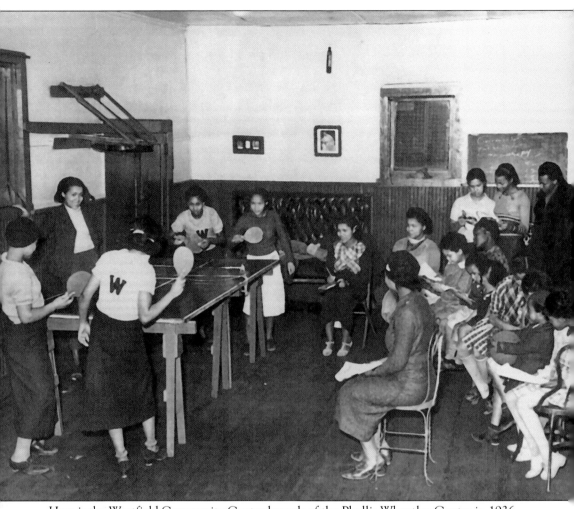
Here is the Westfield Community Center branch of the Phyllis Wheatley Center in 1936.

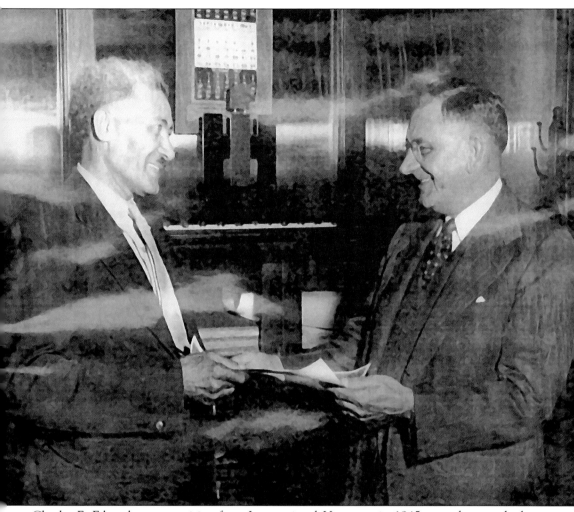
Charles E. Edwards, upon retiring from International Harvester in 1945, was photographed. Edwards had worked for the company since it came to Fort Wayne in 1922.

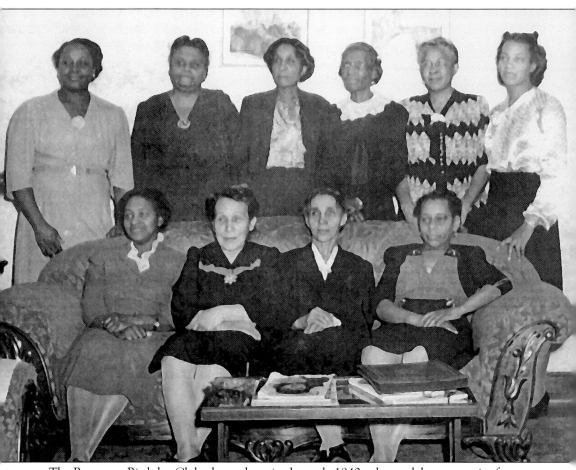

The Rosemary Birthday Club, shown here in the early 1940s, threw elaborate parties for members' birthdays. Not one of the 12 members shared a birthday month.

This photo shows Marie (Dixie) Bass, Mrs. Dorothy Dixie's mother-in-law.

Here is the Bass family. This photo was taken before the 1950s.

Carla Greene and Janie ?, Bass family relatives, are shown here c. 1940.

This photo, dating from 1955–1960, shows Delores and Karen Dixie.

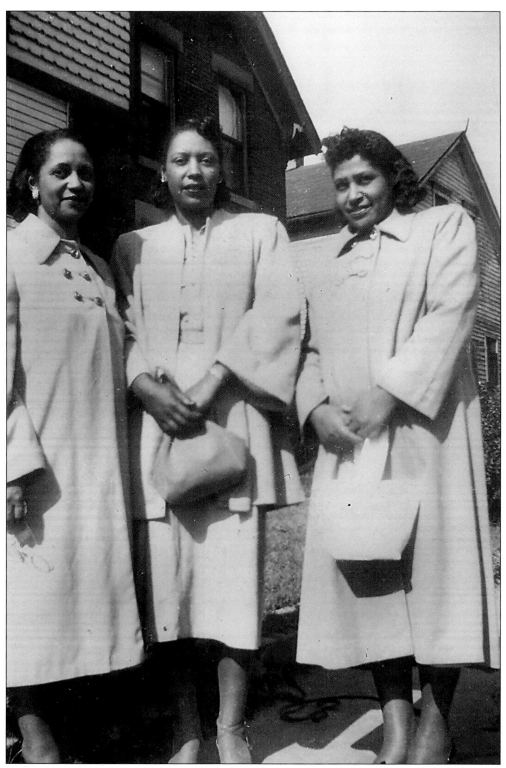
Pictured here are Marie ?, and Leone ?.

These unidentified children are believed to be either Bass or Dixie family relatives. The photo dates to the early 1900s.

Dorothy Jean Dixie, her husband Floyd, and their child (name unknown) are pictured here in the 1950s.

Leone ?, Dorothy Dixie's aunt, is shown here at the far right. The other people in the photograph are unidentified.

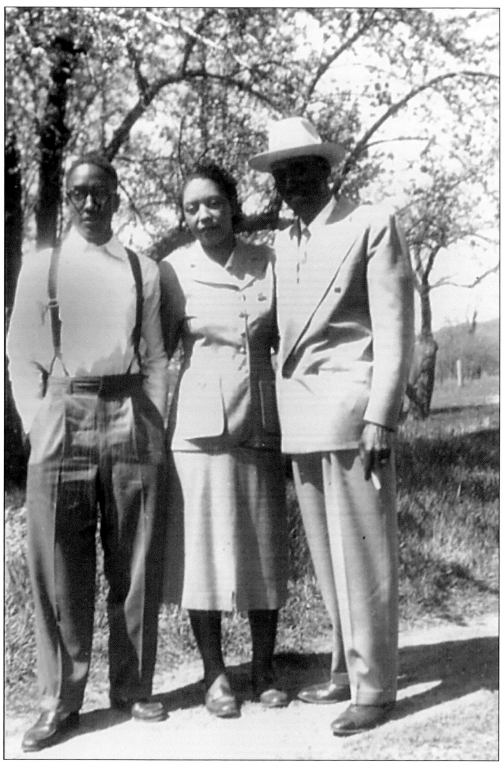
This photo of unidentified Fort Wayne residents was taken c. 1940.

Here is Teresa Dixie in the 1930s or '40s.

Marie Bass is shown here in 1960.

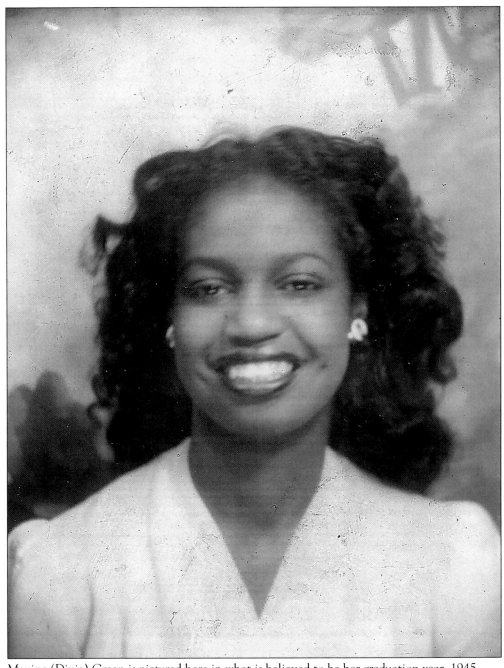

Maxine (Dixie) Green is pictured here in what is believed to be her graduation year, 1945.

This photo, c. 1915, shows Ethel Morgan.

Clarence Dixie and Robert Tyler are pictured here c. 1915.

This pre-1900 photograph shows the Morgan family, ancestors of Dorothy (Bass) Dixie.

Pictured here is an unidentified Dixie or Bass relative—the year is unknown.

Pictured here is an unidentified relative of Dorothy Dixie, c. 1940.

This sketch depicts Zechariah Morgan.

This unknown Dixie or Bass family relative is shown at the turn of the 20th century.

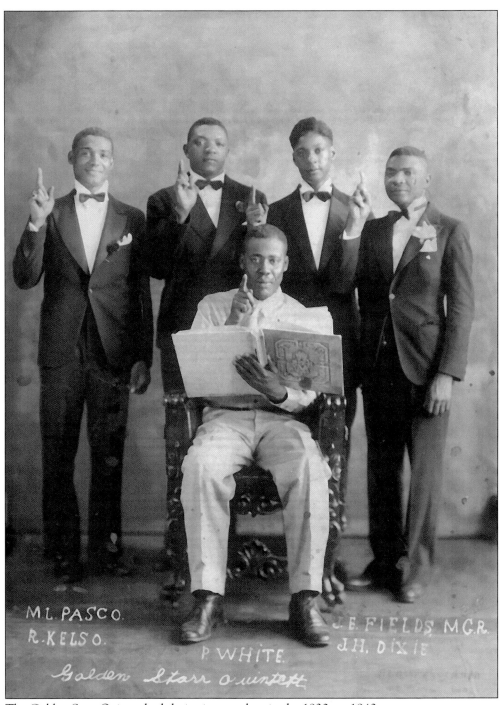

The Golden Starr Quintet had their picture taken in the 1930s or 1940s.

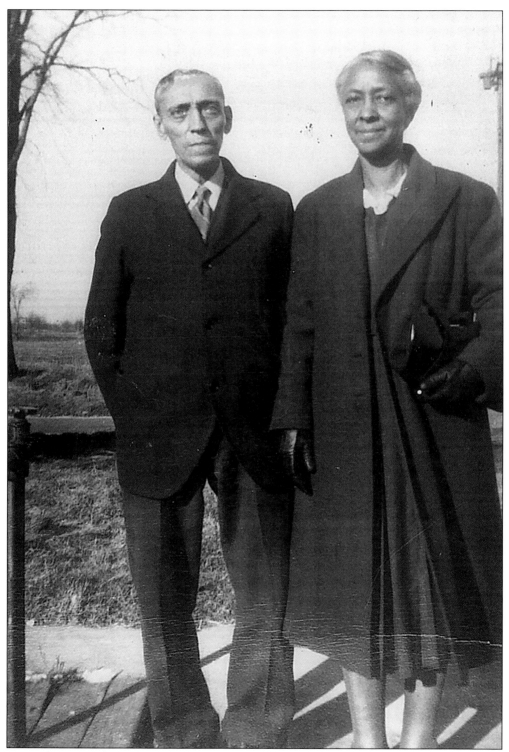

Mr. and Mrs. Zander Bass are shown here in the 1940s or 1950s.

Chris Dixie is shown here c. 1950.

This photograph shows John Dixie Sr. The year is unknown.

This 1945 photo shows Helen G. Dixie.

John Dixie Jr., eight years, nine months, is pictured in 1935.

This is a group of Eastern Star Missionaries.

Shown is Marie Bass Dixie.

This 1920s photograph shows Marie Bass and her sisters (names unknown).

Here is M. Wiggins, c. 1920.

Martha June and John Junior Dixie are shown here in the late 1920s.

Originally Fort Wayne residents, Mrs. Morgan and Mr. Sheets are shown receiving pensions in Michigan. Mrs. Morgan is the grandmother of future Fort Wayne resident Dorothy Dixie. The year is unknown, although the photo probably dates to the 1940s.

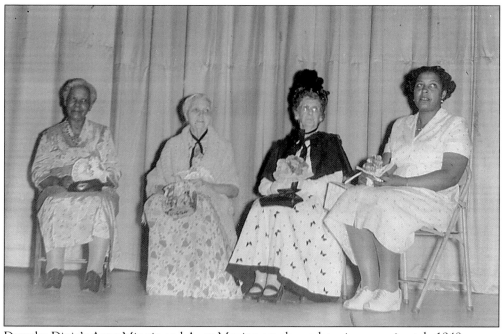

Dorothy Dixie's Aunt Minnie and Aunt Maxine are shown here in approximately 1948.

Dorothy and John Dixie Jr. are pictured above, c. 1960.

Mary Morgan's 100th birthday was celebrated in 1944.

Dorothy Dean and family are shown here in the 1950s.

Three

BLACK CHURCHES IN FORT WAYNE

Information in this chapter has been derived from research compiled by Miles S. Edwards, Ph.D., titled "Fort Wayne's First African American Churches: 1849–1949."

Turner Chapel A.M.E. bears the distinction of being Fort Wayne's oldest black church. Currently located at 836 East Jefferson Blvd., Turner Chapel had been located on previous sites.

Three men are credited with the formation of Turner Chapel in 1849. They are Willis W. Elliot, Henry H. Canady, and George W. Fisher. The three are reported to have bought property at Hanna and Francis Streets at auction. They outbid others by paying the lot's actual value. The relative youth of the group is worth noting: Elliot was a 38-year-old North Carolina native who owned two barbershops in Fort Wayne, and Fisher was a 24-year-old from Ohio who worked as a lather.

When the trio received the property deed, they were not listed as church trustees, thereby subjecting the proposed church to property tax. It seems that quick thinking led Elliot, Canady, and Fisher to seek the advice of the A.M.E. Bishop of the Indiana District. The property was sold to Reverend George Nelson Black, 34, who worked as a blacksmith. The three original purchasers bought the land back from Reverend Black, and this time it was deeded to the Trustees of the African Methodist Episcopal Church of Fort Wayne and the State of Indiana.

For reasons unknown, no building was erected on the site on Jefferson between Hanna and Francis Streets. The three purchasers of the land were slated to serve as trustees, and Reverend Black was to be pastor, but the land was sold in 1853 at its original price and Turner Chapel remained without a building. As was the tradition, however, members more than likely gathered in each others' homes throughout the 1860s. By 1869, the local A.M.E. congregation was large enough to warrant a more permanent structure.

Reverend Nixon Jordan was the church's first permanent (possibly full-time) pastor, and the church met at Hafner's Hall. By 1871, the congregation of Fort Wayne's first A.M.E. church purchased the building that was formerly St. John's German Reformed Church. Shortly after the purchase, the building was relocated to an East Jefferson Street lot (not the 836 E. Jefferson site). In 1917, Turner Chapel moved into a location on Wayne Street. Emerine Hamilton

donated the new lot for the church. The church was named after Bishop Henry McNeil Turner, a black Civil War Chaplain who served in the Tenth Calvary of the United States Army. Turner Chapel moved to its current site in the 1960s.

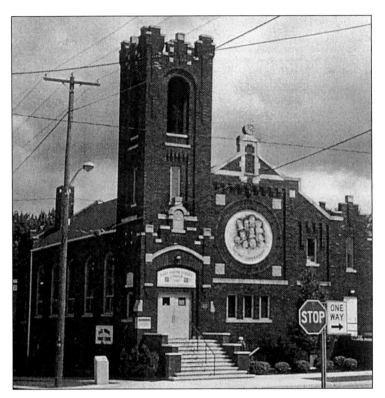

The congregation moved into Turner Chapel on Wayne Street in 1917.

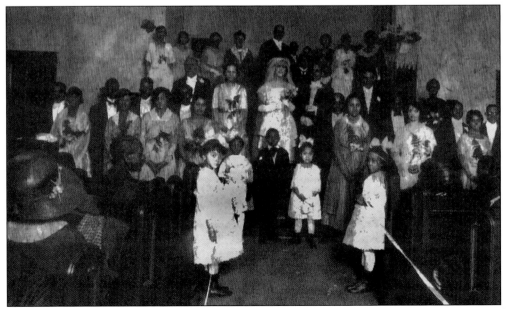

This is a womanless wedding at Turner Chapel in 1922.

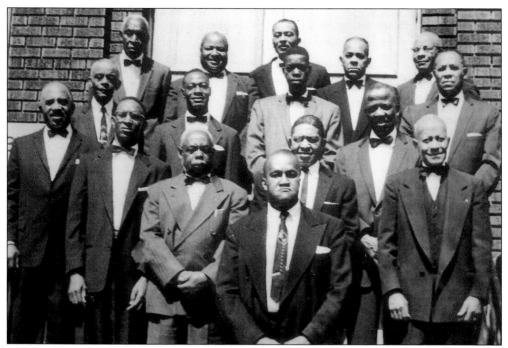
This 1940s photograph shows the men's chorus of Turner Chapel.

Ms. Grace Brooks, a longtime member of Turner Chapel, is shown here in 1951.

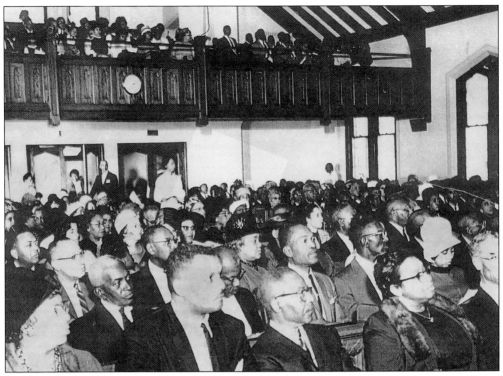
This early 1960s photograph shows the Turner Chapel congregation.

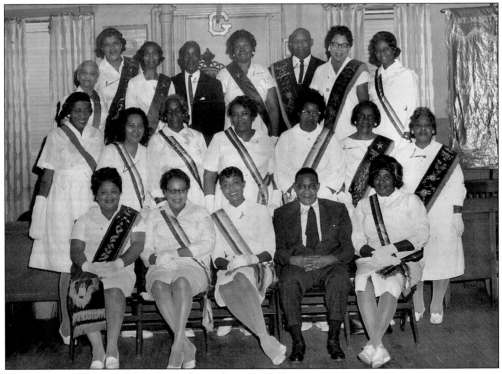
Missionaries of Turner Chapel are shown here in 1967.

Saint John C.M.E. is located at 2401 Calhoun Street. Originally, C.M.E. stood for "Colored Methodist Episcopal," after a meeting of white and black Methodist Episcopals in New Orleans, where the blacks asked to be separate and were granted permission. The group was started in Fort Wayne in 1926 by Reverend Willa Smith and her husband, Dewey Smith, who was credited as the church's co-founder.

The church had other locations prior to arriving on Calhoun Street. One of the earlier sites included Douglas Street, the former site of the Old Jewish Synagogue at Wayne and Monroe Streets. The church was originally named St. John C.M.E. Temple.

The distinction of "Colored" was dropped by the group nationwide in 1954, and the "C" now stands for Christian.

The membership of this branch is rather small compared to other Methodist Episcopals. It has 3,000 churches and 900,000 members. The A.M.E. church is the largest, with 8,000 churches nationwide and 3.5 million members. The African Methodist Zion (AMEZ) has 3,098 churches and 1.2 million members.

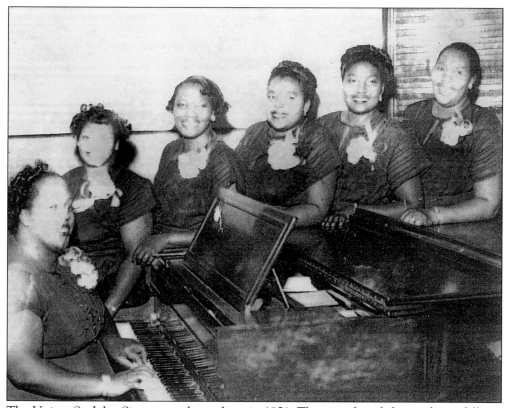

The Union–St. John Singers are shown here in 1951. They are, from left to right, as follows: Henrietta Warner-Jones, Geraldine Renfro, Evelyn Wespon-Hill, Laverne Burnett, Essie Watson, and Ladelia Person-Holmes.

Neighborhood Methodist Church was located at 2004 John Street. Its congregation has since joined Christ United Methodist Church, located at 1101 McKinnie Street. Neighborhood Methodist began as the Methodist Church's means to offer assistance to new immigrants to Fort Wayne. In the pre-World War II era, people of various ethnicities benefitted from the community outreach offered by the church. New Americans who were German, Macedonian, Ukrainian, Bulgarian, Russian, Polish, Yugoslavian, Greek, Romanian, Mexican, and Chinese were all touched by the Neighborhood Methodist Church.

After World War II, African Americans began to settle in the John Street area surrounding the Neighborhood Church and quite a few became members. Briefly, the church was known as Christ the King Methodist Church. Reverend Philip H. Harley, an African-American pastor, was appointed in 1956 and remained pastor until 1963.

For reasons unknown, the congregation made the decision to disassemble in May 1968, and the majority of the members went to Christ United Methodist Church.

Union Baptist Church was the first Baptist Church to make a permanent home in Fort Wayne. It is currently located at 2200 Smith Street. Union is believed to have been established in 1892 by a group of African Americans in Fort Wayne. The church's first site was on Brackenridge Street. Before building at the new site, the congregation worshiped in a house behind a lot on 421 East Brackenridge Street. Construction of the new church began October 11, 1915, and Reverend Graham Jordan was the pastor. After ten years, Reverend Jordan left to start Mount Olive Baptist church in 1925. Reverend Phale D. Hale assumed leadership at what was to become known as Union Baptist, after he united both churches in 1946. By 1950 there was a new pastor, Reverend Clyde Adams. In 1959, the church at 2200 Smith Street was built and remains there today.

Pilgrim Baptist Church, at 1331 Gay Street, began as a meeting at Mr. Charlie Collins's house on March 2, 1919. A modest structure on Wallace Street was purchased for the group's meetings. This building was previously used as a tool shed by the Max Irmscher and Sons Construction Company.

In 1923, the church moved to the old American Legion Hall Post 148 at South Hanna Street. It stayed there until 1929. Still nomadic, the congregation failed to own a building after ten years of unity until 1929, when it moved into the Phyllis Wheatley Social Center, which was located at East Wallace and Clay Streets. They remained there until 1934. A move toward permanence was made in 1934, when the congregation rented the building at Gay and Eliza Streets. An outright purchase of the property was made, but the building was razed in 1937 because it was too small for the membership. A location in a series of buildings too small to fit its congregation would continue to be a problem for Pilgrim Baptist and its members.

Finally, in 1985, nearly 70 years and many buildings (including three churches) later, the final building went under construction on March 31. This last church was completed on December 20, 1987, and holds about two thousand people. Remarkably, in its more than 80 years in existence, Pilgrim has had only four pastors. They were: Reverend Frank L. Brown, 1919–1930; Reverend Hosea Pinkney, 1930–1931; Reverend Frank L. Brown, who had a repeat term of two months in 1931; Reverend John Dixie, who served from 1931 until his death in 1974; and Reverend Sam Shade Jr., who began to pastor Pilgrim in January of 1975 and continues to serve.

Shiloh Baptist Church. The complete history is not known. We do know that it was founded in 1923 by a Reverend J.R. Sims, who came to Fort Wayne from Hope, Arkansas. The church was first located in the Rolling Mills area, also known as Westfield. The church now stands at 2200 Covington Road.

Saint John Baptist Church received its start in 1925 by Reverend J.P. Barber. Reverend P.L. Drinks built the church's new building in 1951 and served in the capacity as pastor until 1967. In 1967, a new building was erected at the church's present site at 2421 Hanna Street; that same year, Reverend J.W. Bledsoe became pastor and remains there.

Friendship Baptist Church grew out of a 1946 prayer meeting at Mr. and Mrs. James Brunson's home. The Brunsons lived at 611 Brackenridge Street. Several ministers were integral to the founding and development of Friendship Baptist Church. On December 29, 1946, the Reverends Shepard, Causey, and Heard began to organize the church. Reverend Causey was elected pastor, and in March 1948, he became senior pastor. On June 7, 1951, Reverend P.H. Love was elected pastor, and he still serves in this capacity. Friendship Baptist is located at 451 East Douglas Street.

Several other churches also started rather early in Fort Wayne. The McKee Street Church of God, now called the New Life Church of God, located at 1201 McKee Street, was started in the summer of 1901 by Benjamin N. Longerbone. The Dupree Temple Church of God in Christ, at 1231 Hayden Street, was started in 1920. John H. Boone was its first pastor; the Right Reverend John Dupree is the current pastor. Christ Temple Apostolic Church, at 1327 Winter Street, started as a prayer group in 1929. On July 4, 1932, the name Christ Temple was assigned to it. The current building was erected in 1950. One of church's first pastors passed away in 1996. East Chestnut Street Church of Christ, located at 3601 East Chestnut Street, follows a non-instrumental music fellowship program. Established in 1947, its first location was the corner of Hanna and Madison Streets, the current location of Friendly Cleaners. Brother Greg Conely is the church's present pastor.

Reverend John Dixie Jr. is shown here in the 1960s.

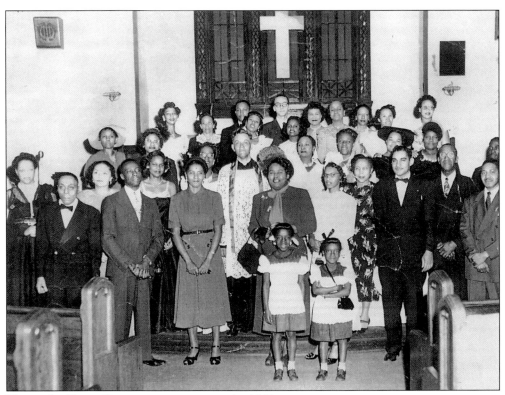

Here is the Union Baptist congregation in the 1940s.

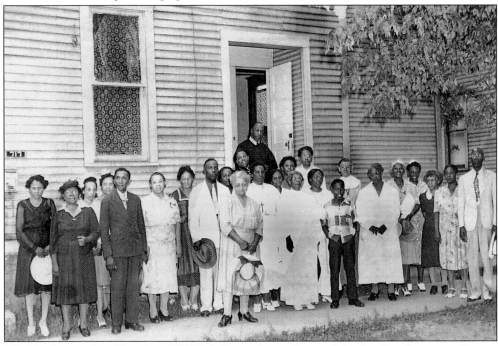

The Fundamentalist Church at 717 High Street featured one of the first female pastors. Reverend ? Zion is pictured in the center of the last row.

This is Bishop John Dupree of the Dupree Temple.

This scene shows a Tom Thumb wedding in the 1940s or 1950s, possibly taking place at Pilgrim Baptist Church.

Another Tom Thumb wedding is pictured here.

Here, the Dixie family is pictured in the 1930s. They are, from left to right: John Jr., Gwennie, Teresa, and Maxine Dixie with Maxine Collins.

An after-service reception for the pastor at Pilgrim Baptist was held c. 1960. Pictured, from left to right, are: (front row) Teresa Dixie, unidentified, John H. Dixie, unidentified, Maxine Dixie, John Jr., and Dorothy Dixie; (back row) unidentified, unidentified, unidentified, unidentified, unidentified, Ernestine Horne, William Dixie, and Katherine Dixie.

The Pilgrim Baptist's choir performed at the Embassy c. 1960.

Four

BLACK FIRSTS IN FORT WAYNE

The list of African American firsts that took place early in the 20th century may come as a surprise to many. The occupations that were considered groundbreaking, if held by black people 50 or so years ago, are now taken for granted. The trailblazers of yesteryear are to be remembered for their bravery. They literally went where no person of color had gone before, and their lack of fear in the face of blatant hatred is an inspiration for everyone.

Many people featured in this chapter did not accept positions simply to be "first." Instead, they discovered what their passions were and followed them. The fact that they made history in the process is a fact to be made much of by later generations.

Dr. Levan Scott, who is listed in this chapter, will have an elementary school named after him starting in the 2000–01 school year. The Levan R. Scott Academy was formerly known as Southern Heights Elementary School. Also, the addition of the city's first black fire chief has not gone unnoticed. However, the focus of this book is primarily the first two hundred years. Those events occurring in the late 20th century can be included in the account of the next two hundred.

- Policeman: Arthur Williams
- Justice of the Peace: William Briggs Sr.
- Attorney: William Briggs Sr.
- Undertaker: Ellis Micheaux
- Doctor: Dr. O'Conner
- Entrepreneur: William Warfield
- Postman: Edwin First
- Township Investigator: Carrie Wilson
- Social Worker: Edna Roland Charlton
- Restauranteur: Missouri Bailey
- Billiard Parlor: Ernest Jones
- Dry Cleaning Establishment: Charles Green
- Tavern: Charles Green
- Filling Station/Grocery Store/Laundromat: Herman Babb
- Dentist: Robert Stanton
- Urban League Executive Director: Robert Wilkerson
- Beauty Shop: Zona Bell Lester
- Barber Shop: Henry Williams
- Lady Barbers: Brady Greenwell
- Podiatrist: Sam Bradshaw
- Orchestra (leader): Suzanna Jordan
- Director NYA Playground: Corinne Brooks
- Barbeque Business: Gene Roach
- Exterminator: Carl Wilson
- Delivery Service: John T. Bryant
- Carpenter (at Rolling Mill): Agustus Bryant
- Hotel: Thirman and Margaret Howell
- Teenage Club: Thurston and Vernon Howell
- Record Shop: Wilma Ferguson
- Church: Turner Chapel A.M.E. Church
- Newspaper Carrier: Mr. Sullivan
- Package Store: Beauford and Henry Williams
- Park: Booker T. Washington (named after)
- Community Center: Phyllis Wheatley (named after)
- Cultural Center: Madam Hicks
- Recreational Hall: Johnson's Hall
- Assistant Buyer for Wolf and Dessauer: Norman Lee
- Salesman for Wolf and Dessauer: Slyvester Miller
- Drug Store: Clarence Haynes
- Pharmacy: Raymond Haymen
- City Council Member: John Nuckols
- County Council Member: James Blanks Jr.
- Teacher: Gloria Morton-Finney
- Male Principal: Levan Scott (believed to have been the first school administrator in Fort Wayne to celebrate Black History Month)
- Female Principal: Verna Adams
- PTC Bus Driver: Lewis Simms
- Building Contractor: Roosevelt Barnes
- Electrician: Johnny Hayes
- Plumbing Contractor: Harold Stith
- High School Dean: WilliamWatson
- High School Coach: A.C. Eldridge

- MLK Montessori Schools: Gloria Jones
- Deputy Superintendent of Schools: James Easton

Brief facts. . .
- 1809: David Gillen first known free black in Fort Wayne.
- 1850: 82 blacks in Fort Wayne.
- 1900: The black population is .06% of the white population (276 vs. 45,115)
- 1910: The black population is up to 572 (or .09%).
- 1917: Pennsylvania Railroad brought in a number of blacks as strike breakers.
- 1920: Black population is 1,454 (or 1.7%). Heavier industries, such as Bass Foundry and Rolling Mill, send representatives south to recruit black workers.
- 1930: Black population grows to 2,360.
- 1940: Black population is 2,517.
- 1941: First blacks hired as factory workers at General Electric in Fort Wayne.
- 1949: Fort Wayne had the following black professionals: one architect, one mortician, five social workers, two lawyers, one dentist, and two doctors. Twenty-nine black businesses in Fort Wayne employed 63 people.
- 1950: The population has doubled in ten years, and now numbers 5,344.
- 1952: First black teacher is hired in Fort Wayne Community Schools.
- 1959: First black is elected to City Council.
- 1960: The black population is 11, 645, or 7.2% of the majority population.
- 1965: The first black male school principal is hired.
- 1970: The black population is up to 19,678.
- 1971: The first black female principal is hired.

Arthur Williams, the city's first policeman, is pictured in 1917. He drove a paddy wagon and was not permitted to arrest whites.

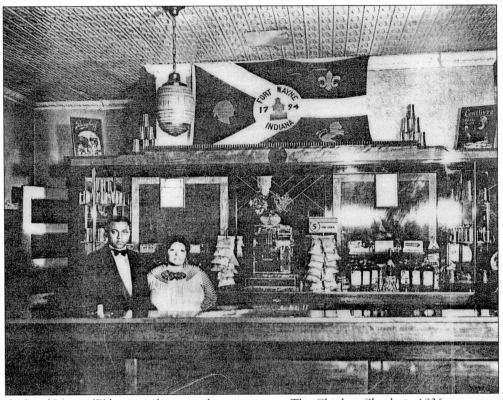

Carl and Mamie Wilson are shown at their restaurant, The Chicken Shack, in 1936.

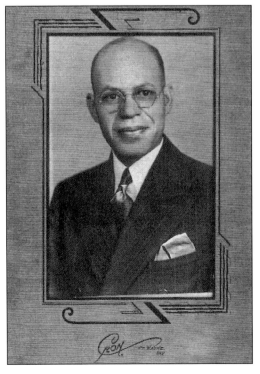

Ellis Micheaux opened his funeral home in 1925. Micheaux's was actually the second in town, but the very first failed soon after opening.

Samuel Stuart II is pictured in 1941. He was the first black valedictorian at Central High School.

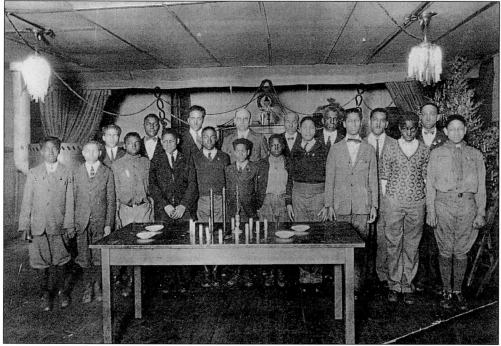

Pictured is the first black Boy Scout troop in 1922.

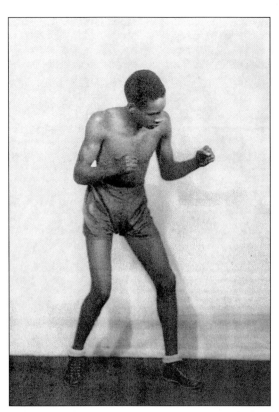

William H. Edwards Sr. was the first black Golden Gloves champion in 1933.

Laura Jackson (first from the left) was the city's first black policewoman. She patrolled an area around Brackenridge Street, known as a black neighborhood. She was hired in the 1920s.

Shown at right are some of the first black police officers hired.

A barely integrated basketball team of Central High School is shown here in 1935.

Theodore Borders was an early black physician in the 1930s.

Mrs. Emerine Hamilton was one of the first black restaurant owners in the 1930s.

Mamie Smith was the first professional, black dietitian at Lutheran Hospital. She is shown here in 1958.

Cleo Smith, the first black graduate of Indiana Technical College, became the first black engineer. He graduated in 1952.

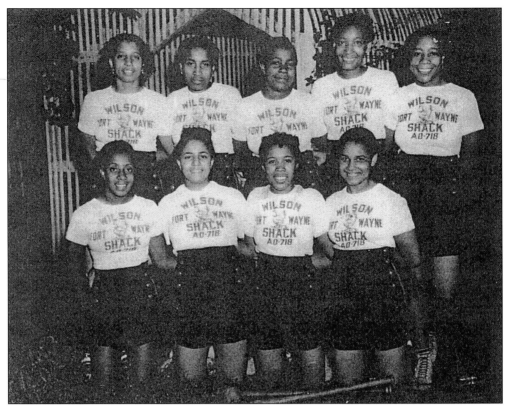
The first girls' softball team, sponsored by Wilson's Chicken Shack, is pictured in 1936.

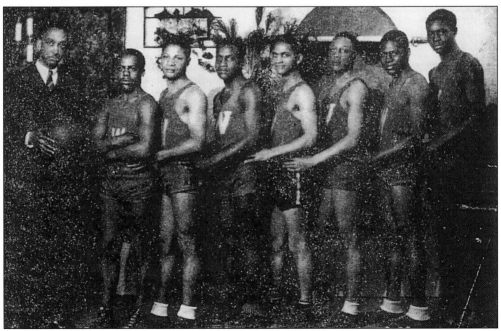
The above photograph shows the 1928 Wheatley Center basketball team.

Henry Childrey Sr. was the first black plasterer. He is shown here in 1917. Childrey did a lot of work for the Embassy Theater.

Zona Bell Lester was one of the first beauty shop owners in the 1930s.

William Briggs was possibly the first black attorney in Fort Wayne in 1936. He was certainly the first black Justice of the Peace in 1938.

Levan R. Scott was the first black, male principal in the Fort Wayne Community Schools in the 1960s. He is believed to be the first black administrator to celebrate Black History Month.

This is a song cover from a Warfield composition.

Another of Warfield's compositions is pictured here.